POSTCARD HISTORY SERIES

St. Charles

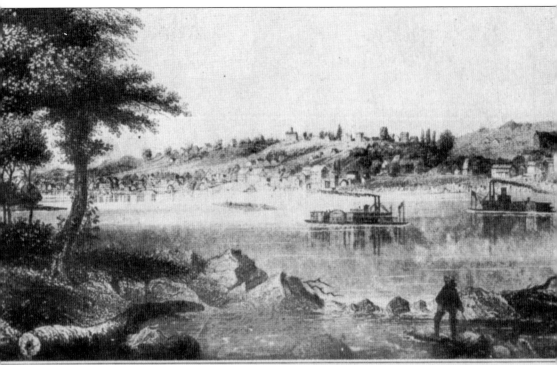

Saint Charles in 1830

This 1830 illustration of St. Charles, Missouri, reveals much about the area at that time. St. Charles is seen from St. Louis County, across the Missouri River. The French settlers of the 1700s called the town Les Petites Côtes, or the Little Hills. It was built on small hills above the Missouri River. The river was the major means of transportation, and steamboats were a common sight. Railroads and bridges would not arrive until the 1850s and 1870s, respectively. (St. Charles County Historical Society.)

ON THE FRONT COVER: The W.A. Meier Terminal Buffet and Rooms building, adjacent to the Highway Bridge, was an ice cream and refreshment stop soon after the bridge opened in 1904. Operated by bridge toll keeper Lawrence Schoenberg, it served the throngs of thirsty commuters crossing the bridge on the new electric railcar, and later, in automobiles. Each day, hundreds of people crossed the bridge that connected the city of St. Charles to St. Louis County. In the days before billboards dotted the landscape, companies paid building owners to let them use their exterior walls as advertising vehicles. Names, illustrations, and slogans were painted directly onto brick walls. For many decades, Hyde Park Beer was brewed in one of St. Louis's predominantly German neighborhoods, and advertisements for the beverage appeared on the sides of buildings throughout the area. (St. Charles County Historical Society.)

ON THE BACK COVER: During extended periods of subzero temperatures, the Missouri River froze. Using picks, ice saws, hooks, and tongs, enterprising individuals harvested and stored in sawdust large blocks of ice to use in the summer. The winter of 1883 was bitterly cold, and ice on the river reached 18 inches thick in some places. On February 3, a warm rain and rising water cracked the ice into large floes that encroached on the riverbanks. The unusual display attracted the attention of St. Charles residents, some of whom stood upon the marooned floes for a better view of the heaving river. (St. Charles County Historical Society.)

POSTCARD HISTORY SERIES

St. Charles

Valerie Battle Kienzle
with the St. Charles County Historical Society

ARCADIA
PUBLISHING

Published by Arcadia Publishing
Charleston, South Carolina

Printed in the United States of America

Library of Congress Control Number: 2011934178

For all general information contact Arcadia Publishing at:
Telephone 843-853-2070
Fax 843-853-0044
E-mail sales@arcadiapublishing.com
For customer service and orders:
Toll-Free 1-888-313-2665

Visit us on the Internet at www.arcadiapublishing.com

Dedicated to those who have called St. Charles home during the past 200-plus years. Their contributions helped make it a unique river city.

CONTENTS

ACKNOWLEDGMENTS

My deepest thanks are extended to the St. Charles County Historical Society, particularly former archivist William Popp, current archivist Dorris Keeven-Franke, and the many volunteers who endeavor to preserve and protect all things related to St. Charles and its history. I am grateful to all persons who over the years chronicled St. Charles's history in books, photographs, journals, and articles. Their gifts to future generations enable all of us to track our history and progress as a community. And I am especially grateful to photographer and visual historian Rudolph Goebel, whose images of daily life in and around St. Charles allow us to visualize the past and reflect on a former way of life in this vibrant Midwestern city.

All images appear courtesy of the St. Charles County Historical Society.

INTRODUCTION

Although considered a suburb of St. Louis, St. Charles has maintained a distinctive identity for 200 years. Separated from St. Louis geographically by the majestic Missouri River, St. Charles has its own history, features, and cultural influences that have helped to shape its unique civic complexion. The French who first settled here in the 1700s called the area Les Petites Côtes, meaning "the Little Hills." Spanish rulers controlled the area from 1762 until 1800, and by the 1780s, the area was called San Carlos del Misuri, in honor of King Charles IV of Spain and Archbishop Carlo Borromeo of Milan. By 1802, the region was again under French rule, but in 1803, it was annexed to the United States as part of the Louisiana Purchase. The area saw an influx of settlers from the eastern United States, and the name changed to St. Charles. The town incorporated in October 1809, was the state capital from 1821 until 1826, and in March 1849, it became a city.

St. Charles has been called the "Williamsburg of the West." In the late 1960s, the residences and businesses along Main Street had begun to show their age. Peeling paint, crumbling chimneys, and cracked masonry suggested an old and dying town. Some buildings had been torn down. Many businesses had relocated to outlying areas of St. Charles County to support new residential subdivisions that were developing. The first section of the new interstate highway near town had also drawn residents away from old St. Charles. About this time, a small group of forward-thinking residents, who knew the rich and proud history of the town, decided it was worth renovating. Change did not happen overnight. It took years of planning and hard work to bring forth the thriving, aesthetic, and historically authentic town center seen today.

Commercial and residential buildings were painstakingly restored. Sections of St. Charles including 604 acres and 118 buildings were placed in the National Register of Historic Places and became known as the St. Charles Historic District. A stroll down Main Street is like stepping back in time. Drawing visitors from across the country and world are repurposed residences and buildings, signs noting historic events, statues, period costumes, quaint accommodations, outstanding restaurants, annual festivals and celebrations, and the beauty of the Missouri River. St. Charles is fortunate to have residents committed to preserving all manner of items related to its rich 200-year heritage.

The St. Charles County Historical Society has preserved a collection of books, letters, clothing, signs, advertisements, household items, and other antiquities related to St. Charles's early years, including an archive of vintage postcards depicting town people, places, and events. Dating primarily from 1900 to 1930, the collection affords a rare opportunity to study St. Charles's way of life a century ago. A few postcards have been published elsewhere over the

years, but this book presents the only complete archive. Most of the images were taken by Rudolph Goebel, who operated a photography studio in St. Charles from 1856 until 1916. In addition to his studio portraits, Goebel also captured thousands of images of St. Charles's people, places, and events from the early 20th century. He included the famous and the not-so-famous, community triumphs and misfortunes, the times of prosperity and the Depression, and other aspects of life at that time in the small, Midwest river town called St. Charles. From his extensive collection, he began creating postcards around 1900, a time when sending penny postcards had become a popular national and international trend and was called the golden age of postcards.

The historical significance of St. Charles is not just contained in the streets and buildings. This book also touches on some of the distinctive events that, over the years, have provided much of St. Charles's rich and colorful historical texture:

As ordered by Pres. Thomas Jefferson, William Clark and Meriwether Lewis left the St. Charles riverfront in 1804, traveling up the Missouri River in search of a waterway to the Pacific Ocean. The Louisiana Purchase had recently doubled the country's size with land reaching as far west as Idaho. The Lewis and Clark Expedition provided information of vital importance in planning and developing the country's western expansion. Clark later settled in and lived out his life in St. Louis.

Founded in 1769, St. Charles was the first permanent settlement on the Missouri River. In 1821, it became Missouri's first state capital.

Famous pioneer Daniel Boone and his family settled in the area. Boone and his sons were instrumental in creating the Boone's Lick Trail to central Missouri. It became a major artery for settlers traveling west. It connected to both the Santa Fe Trail and the Oregon Trail.

St. Charles is home to Lindenwood University. Founded in 1827, it is the second-oldest college west of the Mississippi River.

In 1956, St. Charles was the site of the country's first interstate highway. The federally funded, nationwide project commenced during Pres. Dwight D. Eisenhower's administration.

Historic Main Street dates to the early 1800s. Today, the area remains a vibrant town commodity, featuring shops, restaurants, accommodations, and historically significant buildings flanking the original brick thoroughfare.

The KATY Trail, located on a former Missouri–Kansas–Texas Railroad bed, is a 225-mile biking and hiking trail that extends from St. Charles across the state of Missouri to Clinton. The first section of the repurposed trail was opened 20 years ago in St. Charles, and it is the longest Rails-to-Trails route in the country.

In recent years, St. Charles has been nationally recognized as one of the top cities to live in the United States by a number of news organizations.

Today, St. Charles residents and visitors enjoy the conveniences of 21st-century living while being surrounded by history. The faces of those who live and work here may have changed, but many of the buildings and the small-town atmosphere remain. The images in this book provide visual testament of the city's heritage during the early 20th century.

One

The Missouri River and Its Bridges

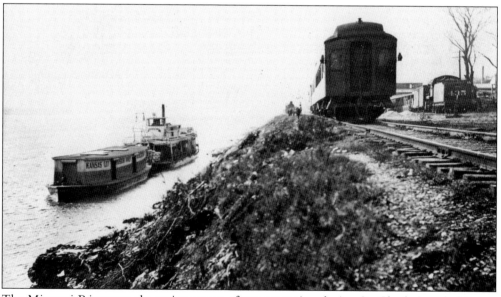

The Missouri River was the major means of transportation during St. Charles's early history. Before the days of bridges and paved roads, steamboats moved people and supplies from place to place. The first steamboat arrived in St. Charles in 1819. Wagons heading west stopped in St. Louis and St. Charles for supplies before continuing their journey. Railroad service came to St. Charles in 1856. The North Missouri Railroad ran daily commuter trains between St. Charles and St. Louis County. The tracks laid near the St. Charles riverfront made it easy to transfer supplies from trains to boats.

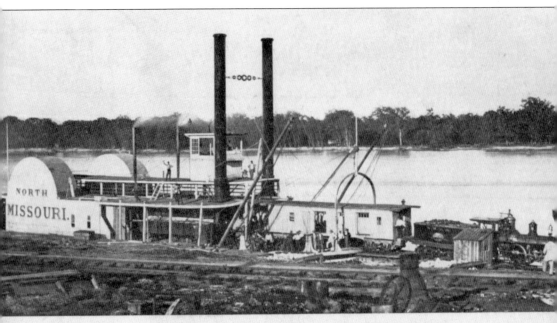

TRANSFERRING TRAINS AT ST. CHARLES, MO., 1869.

St. Charles, Mo.,

In the mid-1800s, ferryboats carried passengers, mail, livestock, and freight across the Missouri River to and from St. Louis County. Later, the first trains were ferried across the river on boats. The 23-mile trip from St. Charles to downtown St. Louis took about six hours. The Wabash Bridge, which opened in 1871, provided an easier connection between St. Charles and St. Louis County. The toll bridge took three years to build. In January 1838, the following advertisement was published: "The subscribers have the pleasure of informing the public that they have commenced running a daily line of four-horse post coaches from St. Louis to St. Charles, leaving the City Hotel at 1 p.m. and arrive at St. Charles to supper; returning, leave St. Charles at 5 a.m. and arrived at St. Louis at 11 a.m."

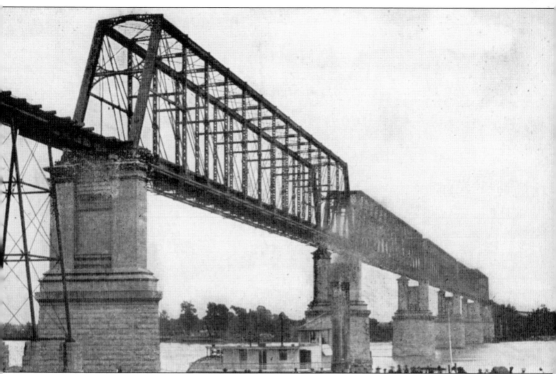

The Wabash Railroad Bridge was the first bridge to cross the Missouri River at St. Charles. Stone piers 90 feet high supported it and provided boats sufficient clearance to pass, even when the water was high. The stone used to construct the piers was hand-cut from rock located along the river's edge. The 2,000-yard bridge cost $2 million to complete. Resident John Buse recalled the dedication ceremony on July 4, 1871: "The day of the dedication of the Wabash Bridge at St. Charles was a great day for the town. The day the Wabash Bridge was dedicated there was a general holiday. A great crowd came to town."

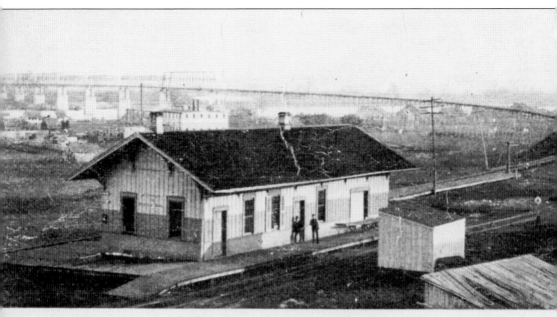

60 Souvenir Postals of St. Charles and Vicinity

WABASH R. R. BRIDGE

St. Charles, Mo.,

At the time the Wabash Railroad Bridge was constructed, large-scale bridge engineering was in its infancy. Builders disagreed about what materials to use. The Baltimore Bridge Company, chosen to build the Wabash Railroad Bridge, settled on cast iron. A few years later, it became clear that cast iron was not the best choice. In 1879, a section of the bridge near the St. Charles side collapsed under the weight of a freight train. The engine remained at the bottom of the Missouri River for about a year before it was removed. In 1881, a second section collapsed, and the bridge was reconstructed of steel. The hanging span design was replaced with overhead spans. In the years before World War I, the trestle work on the bridge approaches was reinforced with concrete. The small building shown served as the Wabash station for the original bridge. The span remained in use until 1936, when a stronger railroad bridge was built nearby.

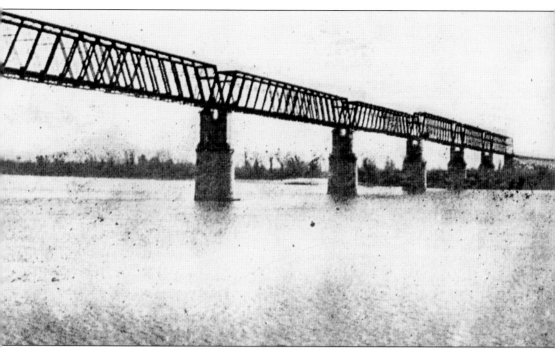

During construction of the Wabash Railroad Bridge, a section of the bridge collapsed, killing 19 workers. The accident was caused by a faulty support cable. The bodies of the victims were recovered and buried together in a circular plot at Oak Grove Cemetery in St. Charles. A tall memorial marks the location. Construction of the bridge soon resumed. In early May, the bridge's strength was confirmed by successfully bearing the weight of six locomotives. The bridge began a new era for those who lived west of the river.

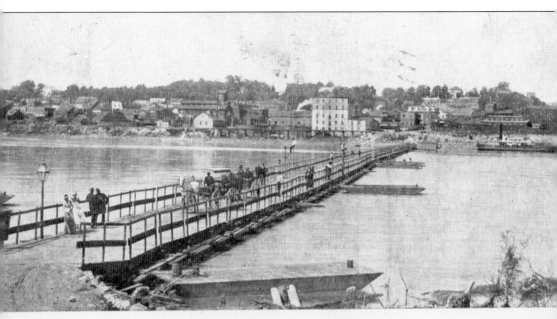

175 Souvenir Postals of St. Charles and Vicinity

St. Charl

THE PONTOON BRIDGE. St. Charles, Mo. LENGH

In the summer of 1890, another bridge across the Missouri River opened. Capt. John Enoch designed a 1,500-foot toll bridge supported by floating pontoons, wood, and rope. The City of St. Charles would not provide funding, so Enoch appealed to St. Louis residents, who decided to invest in Enoch's project. The bridge drew open in the middle to allow boats to pass, but it lasted only five months. An extremely cold autumn upstream hurled large ice floes south into the bridge, destroying it. Pieces of the structure were carried downstream for miles. It was not rebuilt, and some referred to the bridge as "Enoch's Folly."

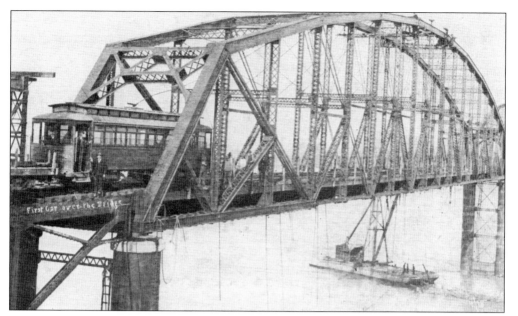

Businessman John D. Houseman brought interurban rail and public utilities to St. Louis in the 1890s. One railroad route ran along St. Charles Rock Road to the Missouri River. Plans for the 1904 St. Louis World's Fair led Houseman to build an electric rail bridge across the river. He worked for five years to make the bridge a reality. In April 1904, he was motorman of the first electric rail across the bridge.

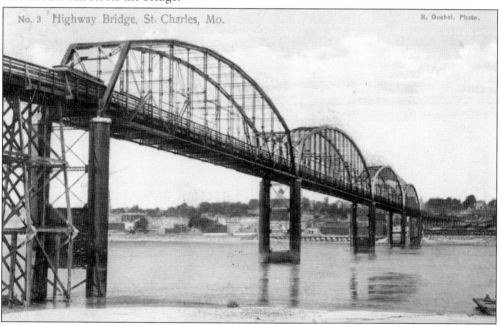

Life in St. Charles began to change in 1904, when the Highway Bridge opened for electric rail, wagons, and eventually automobiles. The new toll bridge was for many years referred to as the Highway Bridge. It was an enormous engineering challenge, and four workers died during its construction. The bridge proved an asset to St. Charles in terms of transportation and commerce.

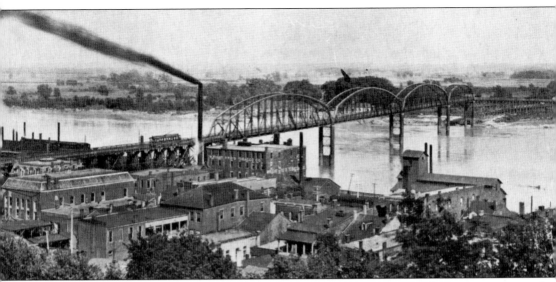

John D. Houseman may have had personal as well as professional reasons for wanting to expand interurban rail service to St. Charles. His eldest daughter was married to Theodore Bruere, a St. Charles lawyer and founder of the St. Charles Savings Bank. Travel time between St. Louis County and St. Charles was greatly diminished when the bridge was complete. The opening of the bridge in 1904 coincided with the opening of the Louisiana Purchase Exposition, the world's fair held in Forest Park. Those taking the interurban rail across the Missouri River could catch connecting trains in Wellston and arrive at other destinations in the St. Louis area. Travel to the world's fair was simplified.

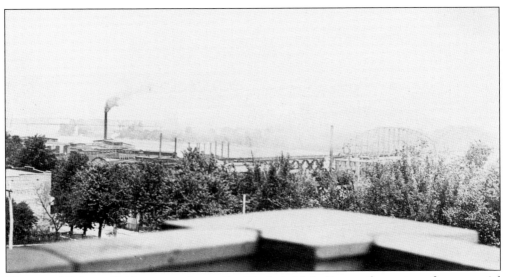

The new Highway Bridge crossed over St. Charles's Main Street, the center of commercial as well as residential life, depositing commuters on Second Street. Over time, Second Street became a business and residential hub, referred to on some old deeds as "the Second Main Street." This view shows the bridge and St. Charles.

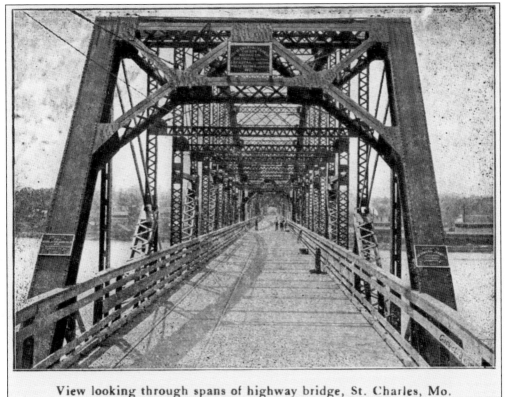

View looking through spans of highway bridge, St. Charles, Mo.

After John Houseman steered the first electric rail across the new Highway Bridge, St. Charles residents Gentry G. and Julius F. Rauch began operating an electric freight car between St. Charles and St. Louis, which simplified trade across the river.

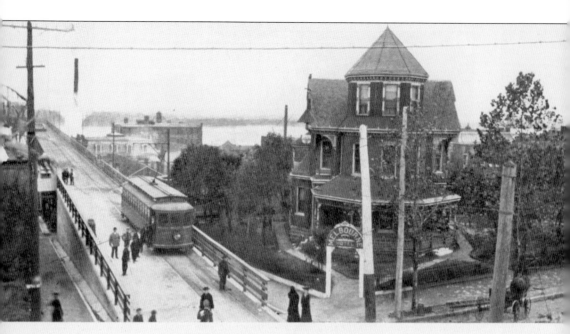

GOEBEL, PHOTO.

HIGHWAY BRIDGE APPROACH.

St. Charles, Mo.,

The Highway Bridge opened up new business opportunities to St. Charles. The Melbourne Hotel was built on the south side of the bridge deck as it entered town. W.A. Singer ran the hotel, which catered to weary travelers wanting to stay near the terminus of the interurban rail. As the years passed and traffic increased, St. Charles hotels suffered. Patrons at lodgings near the bridge often complained about nighttime traffic noise. Freight and livestock vehicles rumbled over the bridge at all hours, keeping patrons awake. Nicer hotels opened on the St. Louis County side of the river, and weary travelers lodged there instead of in noisy St. Charles.

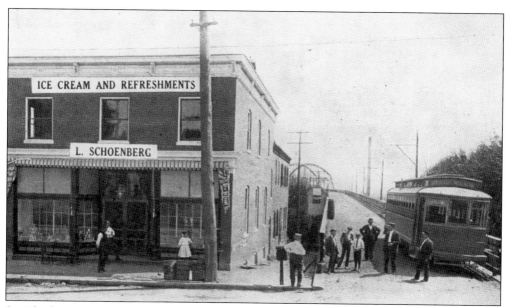

St. Charles resident Lawrence Schoenberg was the bridge toll keeper on the St. Charles side of the river. Hearing (and overhearing) comments and anecdotes of the commuters revealed a common theme. Most were hungry, thirsty, or both. So, Schoenberg opened an ice cream parlor on the north side of the bridge deck, across from the Melbourne Hotel. It was a hit.

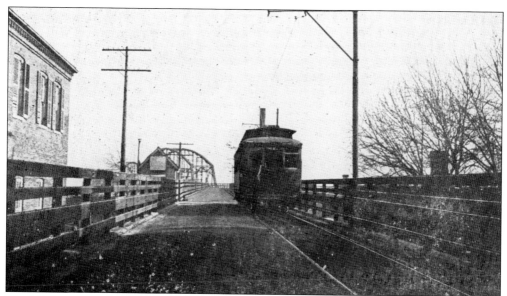

The Highway Bridge charged a toll until January 17, 1932. The St. Louis & St. Charles Bridge Company sold transferable commutation tickets that were good for 40 trips in either direction. The day after tolls were abolished, the last streetcar crossed the bridge. A bus line run by Red Line Bus Company replaced the streetcars.

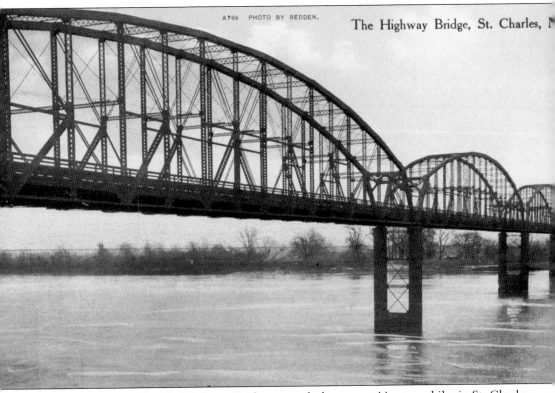

The Highway Bridge, St. Charles, M

In 1909, five years after the Highway Bridge opened, there were 14 automobiles in St. Charles. A taxicab company began operating in town several years later. Vehicles featured the company name painted in white letters on the doors. If the cab was available, a For Hire sign was placed in the windshield. By 1924, there were more than 2,100 automobiles in St. Charles.

With two bridges connecting St. Charles and St. Louis County, travel by train, trolley, and automobile was greatly enhanced. On the Missouri River, riverboats and barges remained popular for shipping cargo such as grains and coal and were a common sight at the St. Charles riverfront.

Highway Bridge from River Front, St. Charles, Mo.

The Highway Bridge was a marvel and popular attraction at the time it opened. It remained in use from 1904 until 1992, when it was permanently closed. By then, years of use and exposure had created structural problems and crumbling surfaces. Generations of St. Charles and St. Louis residents enjoyed the commuting convenience it provided.

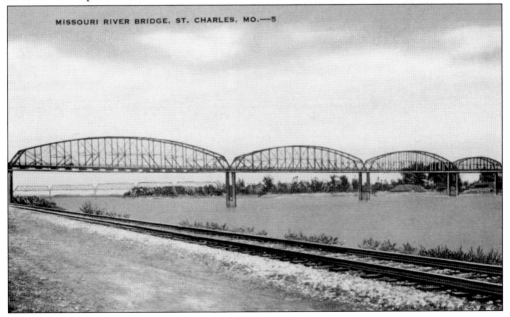

MISSOURI RIVER BRIDGE, ST. CHARLES, MO.—5

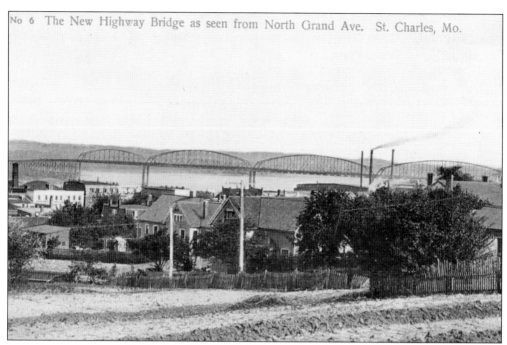

For many years, the Highway Bridge was the only automobile bridge connecting St. Louis County and St. Charles. When the state highway system began, the span became known as the Highway 40 Bridge and, later, the Route 115 Bridge. It was the scene of heavy traffic and congestion in both directions.

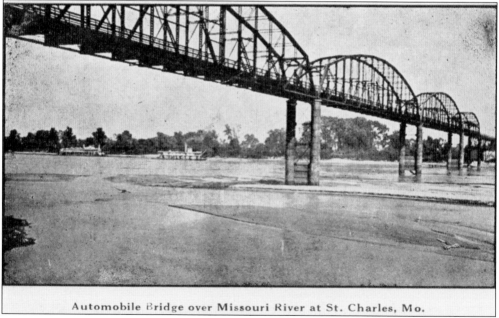

Automobile Bridge over Missouri River at St. Charles, Mo.

Over time, the bridge's wood plank surfaces were replaced with asphalt, and a pedestrian path beside the bridge was added. During rush hour, the bridge became one-way. By the time it closed in 1992, many residents considered it too narrow, antiquated, and dangerous. It was removed in 1997.

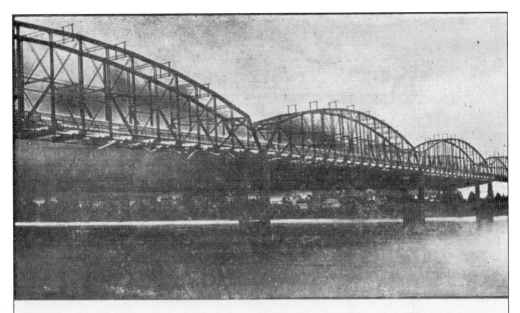

Historical subject: Spectacular burning of St. Charles, Mo., Automobile Bridge, Sept. 26, 1916

The Highway Bridge was in continuous use for 88 years, with one exception. On September 26, 1916, a fire broke out, destroying some of the floor and woodwork. Some speculated that an ember from a tossed cigarette landed in one of the bird's nests under the bridge. Strong winds spread the flames from section to section. Damage was estimated to be from $150,000 to $200,000.

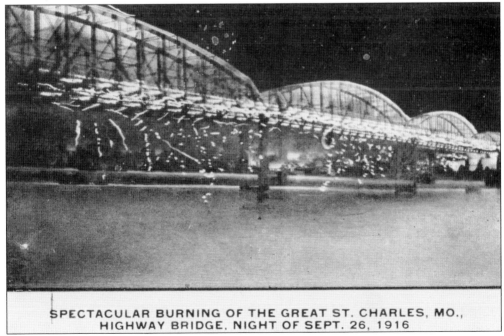

SPECTACULAR BURNING OF THE GREAT ST. CHARLES, MO., HIGHWAY BRIDGE. NIGHT OF SEPT. 26, 1916

The nighttime blaze created an amazing light show. Firefighters from both sides of the river soon discovered that the bridge was too high and their water pressure too weak to extinguish the flames. Spectators watched as sections of the burning bridge fell into the river.

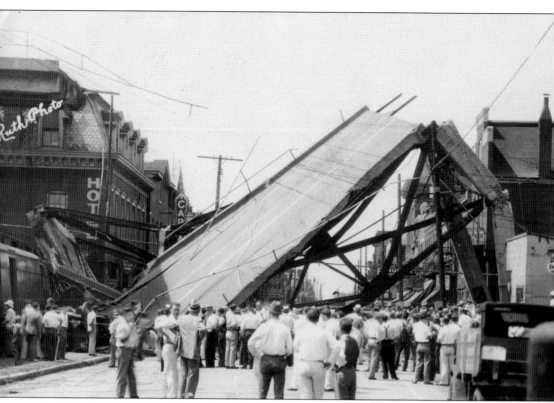

In 1935, a large section of the railroad bridge collapsed onto Main Street as a train was crossing. Several railroad cars became detached, coasted down the track, slammed into the side of the bridge and the adjacent Galt Hotel, and caused a 150-foot section of the bridge and its supports to collapse below.

Two

MAIN STREET AND THE ST. CHARLES BUSINESS COMMUNITY

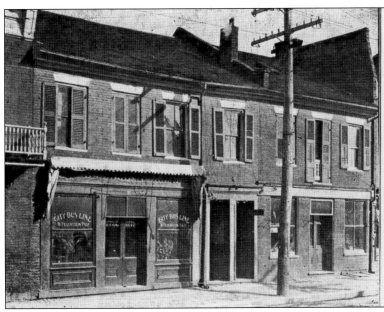

HISTORICAL SUB-JECT:—Building a t St. Charles, Mo., said to have been used as the first legislative hall and seat of government of the State of Missouri. Missouri was the first state entirely west of the Mississippi River admitted to the United States, and St. Charles was designated as Missouri's first capital.

In 1769, St. Charles became the first pioneer settlement on the Missouri River when Louis Blanchette built a cabin home. Missouri became the 24th state in 1821, and for five years St. Charles was the capital. At that time, Charles and Ruluff Peck offered the governor and legislators use of the Main Street buildings shown here. The structures have been converted into a period museum with replicas of the rooms and furnishings used by early lawmakers.

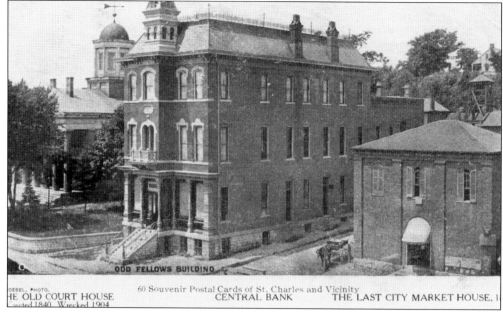

St. Charles has a rich architectural history. Many houses and buildings date from the early 1800s and are preserved today. French and German structural elements and facades reflect the origin of settlers who built them. The building on the far left is the former county courthouse. The building in the center is the c. 1878 Independent Order of Odd Fellows Hall, and on the right is the former city market that was completed in the 1880s.

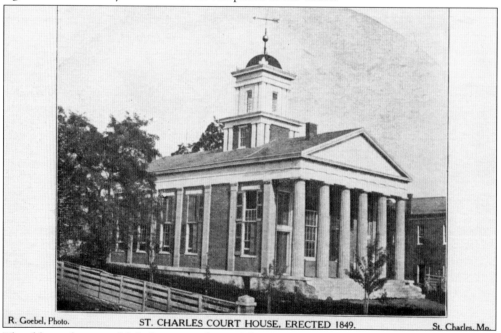

R. Goebel, Photo. **ST. CHARLES COURT HOUSE, ERECTED 1849.** St. Charles, Mo.

The old courthouse on Main Street was the city's legal center for almost 60 years. It was completed in 1849 and was adjacent to the city market and the fish house. Criminal and civil trials took place here. In February 1876, a tornado damaged the right side of the building, destroying three of the Doric columns. The building was repaired and was used as the courthouse until 1904.

26

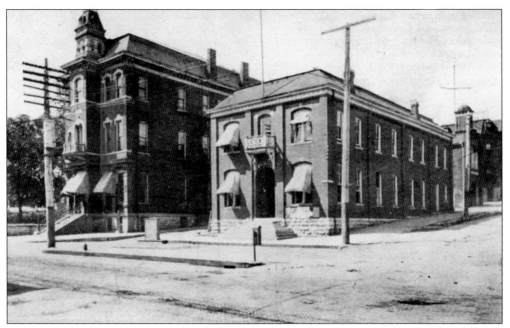

Main Street was macadamized using small compacted stones about 1840 and was paved with vitrified brick in 1897. In the days before surface paving, dust was often a problem. Street-sprinkling wagons were brought across the river from St. Louis to wet down Main Street, thereby reducing the amount of dust stirred up by horses and wagons.

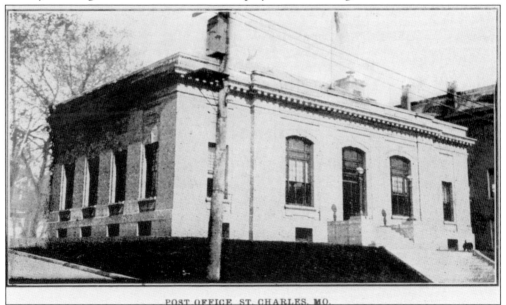

POST OFFICE. ST. CHARLES. MO.

St. Charles established the third post office west of the Mississippi River in 1806. People traveling the western frontier could leave outgoing mail at relay taverns along the main trail, called the Boone's Lick Trail. In St. Charles, free mail delivery began September 12, 1902. The 1906 city directory indicates mail was collected from 43 boxes throughout the city. The post office was open Sunday mornings, and mail could be picked up from the post office window. During the week, mail was delivered twice per day to residences and three times to businesses.

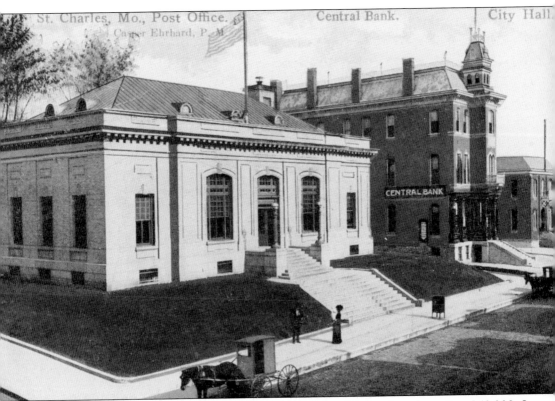

CENTRAL BANK

The US post office was built in 1909 on the site of the old courthouse, costing $60,000. It operated there until the 1960s, when it moved to Fifth Street. Today, the building houses private businesses. Part of the post office sign can still be seen above the front door.

CITY HALL, ST. CHARLES, MO.

The building at the corner of Main and Jefferson Streets has a history. St. Charles was the state capital in 1822, when William Pettus, Missouri secretary of state, saw a need for a public food market. In 1823, he purchased the lot and constructed a market building. It was sold to the City of St. Charles in 1833 and continued to operate as a market until 1886. The building was expanded again and served as city hall until 1973. It was repurposed in 1982 and became the St. Charles County Historical Society headquarters. It is listed in the National Register of Historic Places.

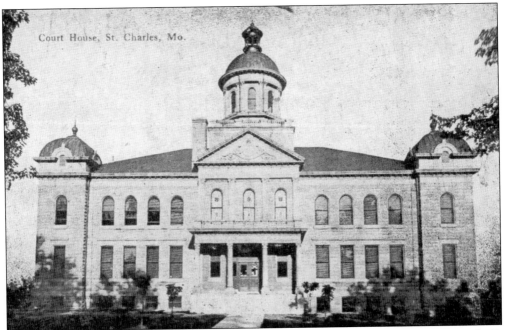

Court House, St. Charles, Mo.

The building referred to for many years as the new St. Charles County Courthouse was built on top of a hill overlooking Main Street and the Missouri River. Work began in 1901 and was completed in 1903. Rock used in the building's construction came from a quarry near Jungs Station Road in the Harvester area of St. Charles County. Initially, the building had no sidewalks or driveways.

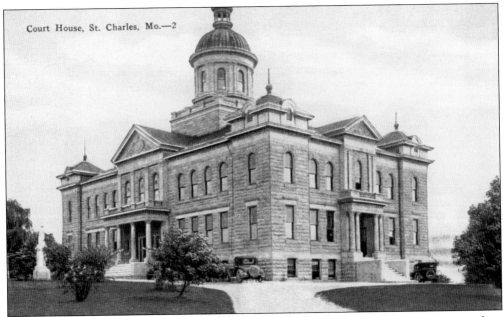

Court House, St. Charles, Mo.—2

The St. Charles County Courthouse building is still used today, but in recent years, a modern court facility was built on Second Street on a portion of the hill below the original courthouse. In years past, St. Charles hotels were filled with lawyers when court was in session.

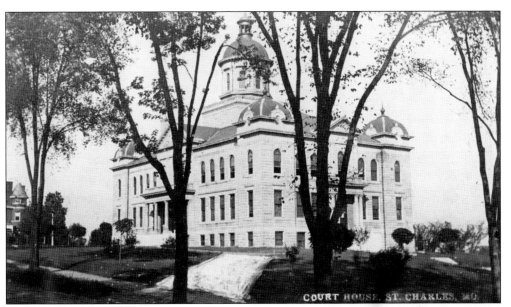

COURT HOUSE, ST. CHARLES, MO.

The St. Charles County Courthouse has been the seen of numerous celebrations and patriotic events through the years. The building was draped in red, white, and blue bunting and patriotic ribbons for Pres. William Howard Taft's October 6, 1908, reception. Graduation ceremonies for various St. Charles County schools also were held on the courthouse grounds in the early part of the 20th century.

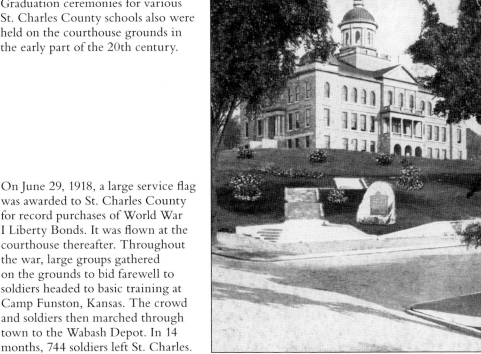

Court House, St. Charles, Mo.

On June 29, 1918, a large service flag was awarded to St. Charles County for record purchases of World War I Liberty Bonds. It was flown at the courthouse thereafter. Throughout the war, large groups gathered on the grounds to bid farewell to soldiers headed to basic training at Camp Funston, Kansas. The crowd and soldiers then marched through town to the Wabash Depot. In 14 months, 744 soldiers left St. Charles.

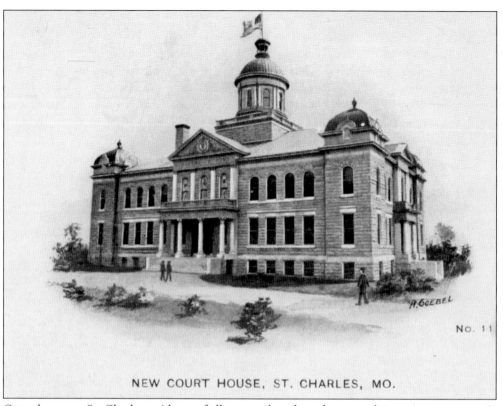

NEW COURT HOUSE, ST. CHARLES, MO.

Over the years, St. Charles residents of all ages gathered on the grounds to enjoy a panoramic view of Main Street, assess the flooded Missouri River, or watch patriotic fireworks displays.

St. Charles has had numerous jails. This 1911 building was St. Charles's fifth jail. Located on South Second Street, it held 44 prisoners. A justice of the Missouri Supreme Court called it "Dante's Hell." The jail contained gallows where six hangings took place before the practice was outlawed in 1935. The jail was used until 1989 and then demolished in 1995.

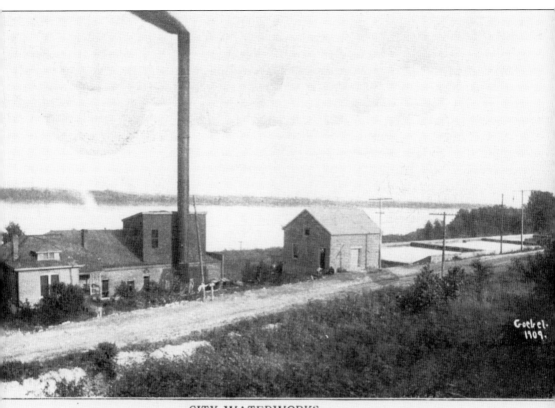

CITY WATERWORKS.

St. Charles, Mo.,

St. Charles's first municipal service was the city waterworks. A livery owner demonstrated how water could be pumped from the Missouri River with a horse-driven treadmill and stored in tanks on his roof. Once stored, water flowed through hand-dug trenches to Main Street or into storage basins. Water mains were laid and buildings were constructed about 1880. The first waterworks building was located at the end of Monroe Street. In 1903, a larger facility and holding basins were built on South Main Street and put into operation.

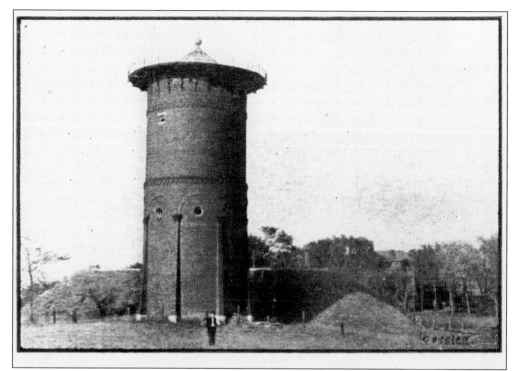

Water was stored in a tower located near Lindenwood College (known since 1997 as Lindenwood University), the city's highest elevation. The tower, 72 feet high and 25 feet wide, was built of brick on a stone foundation with a wood tank on top. Residents were slow to accept water services.

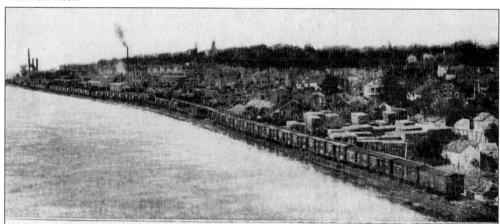

Panoramic View of St. Charles, Mo., From the Wabash Railroad Bridge.
The leading industry of St. Charles is car building. The picture shows two long trains of new cars awaiting shipment.

This view of St. Charles, taken from the Wabash Railroad Bridge across the Missouri River, suggests how closely the city's economic vigor was tied to railroad service 100 years ago. Railroad ingress and egress on the waterfront assured efficient industrial supply lines from the waterfront and the means to deliver new train cars produced locally by American Car Foundry, the area's major industrial employer. The trains shown here were part of the Missouri–Kansas–Texas (KATY) Railroad Company.

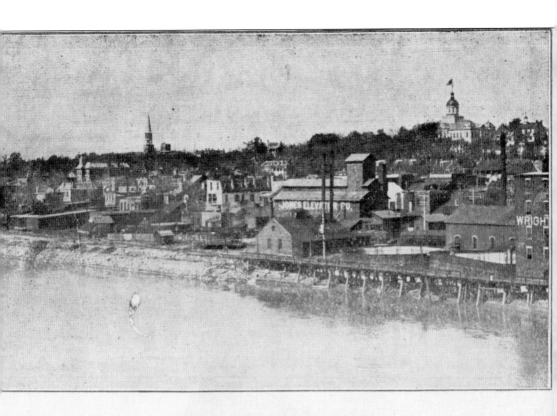

This panoramic view of St. Charles was taken from a boat on the Missouri River. It reveals a vibrant, populous, and prosperous town with a mix of residential and manufacturing facilities, excellent transportation resources, and pleasing topography—all elements that, in the early 20th century, defined a progressive, successful city. The dome and flag of the county courthouse can be seen in the distant right. The tall spire of a church is visible to the left. Various businesses and municipal service operations are near the river's edge.

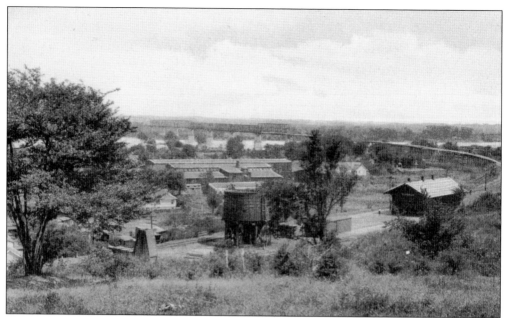

The city of St. Charles was filled with businesses and residential housing by the 1930s, but areas just a few miles from town remained mostly undeveloped and dotted with family farms. The Wabash Railroad Bridge and the Missouri River can be seen in the distance in this photograph taken facing east toward St. Louis. The Wabash Depot is in the foreground.

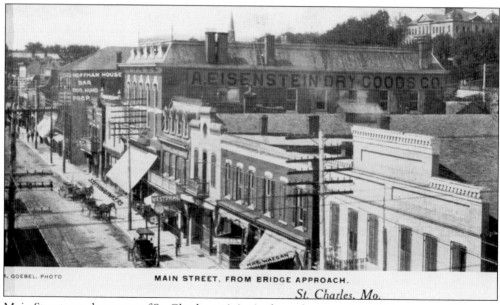

MAIN STREET, FROM BRIDGE APPROACH.
St. Charles, Mo.

Main Street was the center of St. Charles activity in the early years of the 20th century. Although horses and wagons were still the standard method of transportation, electricity and telephone lines meant that this was a progressive city. Multiple dry goods stores, banks, hotels, jewelers, daily and weekly newspaper offices, and bars populated the city's central thoroughfare. The population exceeded 10,000, and the town continued to grow.

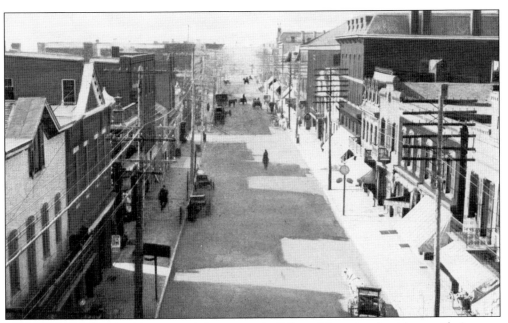

Main Street was lined with two- and three-story buildings. The mix of residents with German and French backgrounds meant that a variety of architectural styles and adornments were used in the construction of the buildings. Most were built with brick manufactured in the area. Retailers often ran their businesses on the street level and lived with their families on the second and third floors.

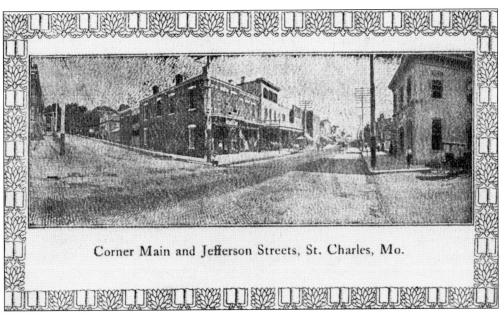

Corner Main and Jefferson Streets, St. Charles, Mo.

Main Street intersected with Jefferson Street near the center of St. Charles's business district. This view facing north on Main Street shows First National Bank, the oldest bank in St. Charles County and the first bank organized here under the National Bank Act of 1864, on the right. The image on this unusual postcard was stamped into soft leather.

Just a short distance west of Main Street, Jefferson Street became a residential area with large homes and lawns. Further west, Jefferson was undeveloped, surrounded by tranquil wooded areas and lush foliage, looking much as it did when St. Charles was first settled.

Jefferson Street, St. Charles, Mo.

First National Bank, organized in 1863, was the city's only national bank. The bank was located in the c. 1853 building where founder Ezra Overall lived. The bank opened during the Civil War as a place where businessmen could safeguard securities. The building was damaged in an 1876 tornado but was remodeled and rebuilt.

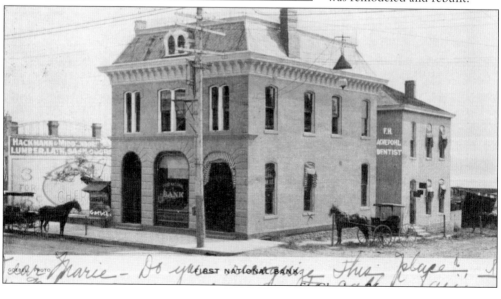

Union Savings Bank was organized in 1870. In 1911, it moved into a two-story Classical Revival building designed by St. Louis architect Albert B. Groves. Located at North Main and Jefferson Streets, the main entrance featured fluted cast-stone columns. A 1916 advertisement for the bank is succinct and to the point: "We want your business."

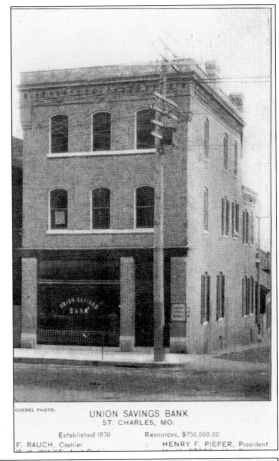

GOEBEL PHOTO.

UNION SAVINGS BANK
ST. CHARLES, MO.

Established 1870 Resources, $750,000.00

F. RAUCH, Cashier HENRY F. PIEPER, President

St. Charles was home to the repair shops for the North Missouri Railroad. When it was acquired by the Wabash Railroad, the repair shops moved away from St. Charles and left behind many displaced workers and a large, empty facility. In 1873, officials decided to build a railroad car manufacturing facility. The company, which provided jobs for many residents, was originally called St. Charles Manufacturing Company, then St. Charles Car Company in 1881, and finally American Car Foundry in 1899.

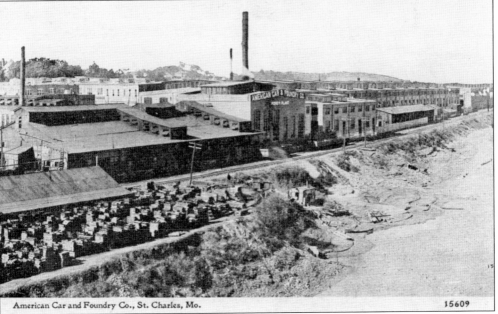

American Car and Foundry Co., St. Charles, Mo. 15609

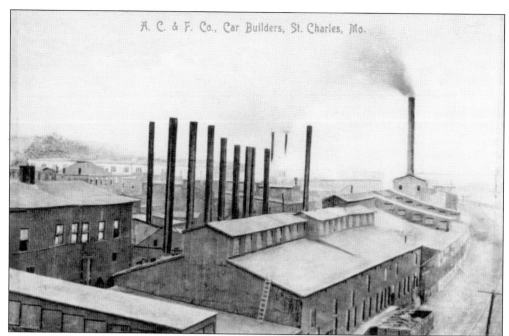

When the railroad car manufacturer opened, it provided employment for many St. Charles residents. Workers were needed with skills in iron, stone, brick, and lumber. Items built by American Car Foundry included horse-drawn streetcars, refrigerated railroad cars, Army escort wagons during World War I, and tanks during World War II.

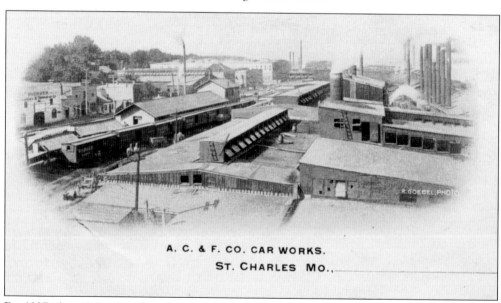

A. C. & F. CO. CAR WORKS.
ST. CHARLES MO.,

By 1897, American Car Foundry and its various buildings occupied almost 20 acres, with 3,000 feet of frontage along the Missouri River. That year, it produced 4,500 freight cars and 175 coach cars. Two years later, the company added 11 acres and 1,000 feet of river frontage. By 1904, American Car Foundry was manufacturing refrigerated beer cars for Anheuser-Busch. Company production peaked in the 1940s with 3,000 employees and then decreased in the 1950s.

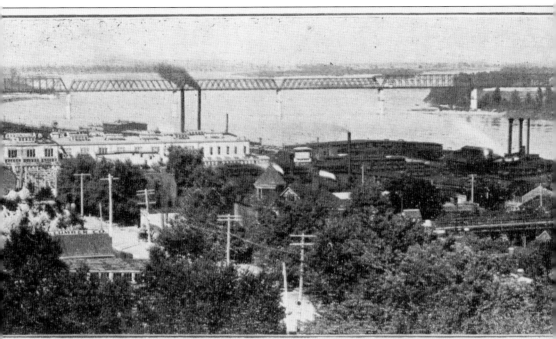

View From the Court House Dome, St. Charles, Mo.

St. Charles was a progressive and prosperous river city in the early 1900s. At American Car Foundry, railcars were being manufactured on a large scale. Numerous large churches of various denominations flourished. The city had both public and private schools. The presence of several local banks is a measure of the city's prosperity. The Wabash Railroad Bridge connected the town with larger St. Louis County. Businesses flourished along Main Street, and fine houses of many varying architectural styles appeared along tree-lined streets. Life in St. Charles was good. The city had come a long way from the days of the early French settlers and the explorers Meriwether Lewis and William Clark.

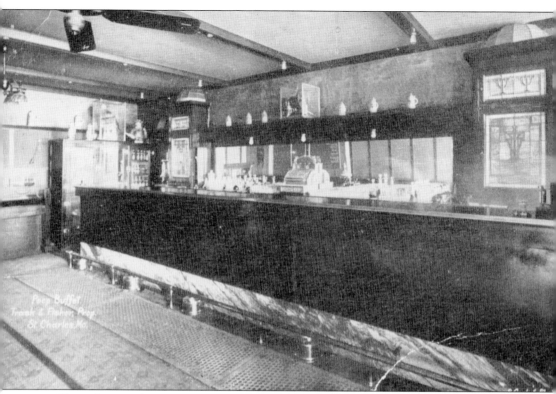

Throughout its history, Main Street has been populated by numerous restaurants and bars or saloons. The 1916 city directory lists 19 saloons, most of which were on Main and Second Streets. Peep Buffet was located in the 100 block of North Main Street during the first half of the 20th century. With dark wood and a large bar, the establishment was a welcome sight for many after a long day. Many of the bars and saloons served draught Moerschel and Schibi beers, both of which were brewed in St. Charles.

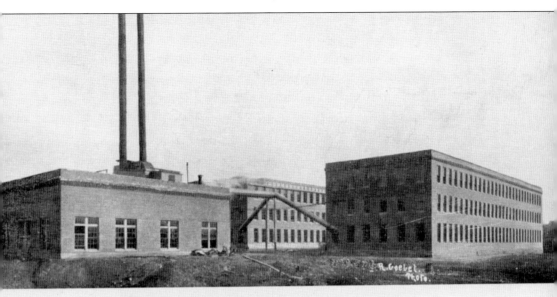

ROBERTS, JOHNSON & RAND SHOE CO. FACTORY.

St. Charles, Mo.

In 1906, a manufacturing facility of Roberts, Johnson & Rand Shoe Company opened, providing employment for hundreds of St. Charles families. In 1911, the company merged with Peters Shoe Company, forming International Shoe Company, which was headquartered in downtown St. Louis. International Shoe Company was a major national producer of footwear for most of the 20th century. More demand for footwear after World War II increased production at the St. Charles facility. At the time, the company employed approximately 1,000 people and produced 8,000 pairs of men's and boys' shoes each day. The plant closed in 1953.

In the 1930s, local businessmen raised money to buy 8.8 acres of land to construct a heel factory, a separate division of International Shoe Company. The land was then given to the company. By the 1940s, 160 workers at the plant produced approximately 10,000 heels per day. Organized labor attempted to get into the plants, and a strike was held in 1945. In November 1949, workers were laid off for three weeks.

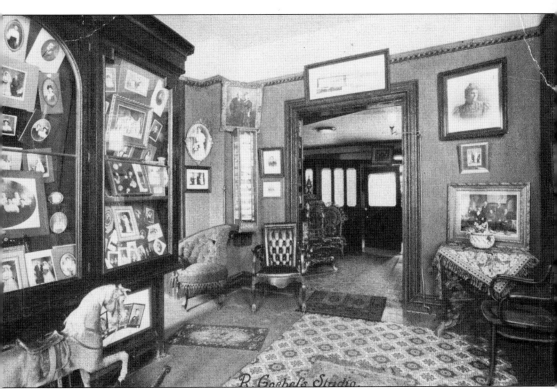

R. Goebel's Studio

German-born Rudolph Goebel came to Missouri to start a new life. He planned to photograph the westward expansion of the day but instead decided to settle in St. Charles. In 1856, he set up a photography studio across from the courthouse on Main Street. He also traveled by wagon throughout St. Charles County. Business was good, and Goebel relocated to Second and Jefferson Streets. His busy career spanned some 60 years, and he produced thousands of images of people, places, and events in St. Charles. He also trained several other area photographers. Shown here is his 1908 studio. Goebel always seemed to have a camera with him, and he was not afraid to climb great heights to capture an image. He was made a lifetime member of the Missouri Historical Society because of his outstanding contributions.

In the years before chambers of commerce, convention bureaus, and mass media advertising, cities and businesses often used postal cards or "private mailing cards" to promote themselves. Civic pride ran strong in this early-20th-century river town. City directories from this period listed with pride the number of banks, businesses, schools, churches, retail establishments, substantial homes, mailboxes, and fire department call boxes to be found in St. Charles. They also noted the number of miles of improved roads, an important detail as the popularity of the automobile increased. This unusual card features embossed pastel flowers and gold foil on a small book that opens to reveal a dozen tiny photographs of major businesses, schools, and sites in St. Charles.

Greeting From
St. Charles, Mo.

Still-life art sometimes was reproduced on postcards, along with the name of the town being promoted. It was not long after the US Congress authorized the mailing of private postal cards, on May 19, 1898, that their popularity soared. Postcards were a quick, easy, and inexpensive way to communicate in the days before telephones and radios. Affixed with a penny stamp, a postcard could travel thousands of miles from the hands of the sender to the receiver. Postcards provided recipients quick updates or views of never-before-seen places. The golden age of postcards, when millions of cards were printed and mailed each year, spanned the first three decades of the 20th century.

Private Mailing Card

AUTHORIZED BY ACT OF CONGRESS OF MAY 19th, 1898.
(POSTAL CARD—CARTE POSTALE.)

Mr. Louis Goebel
Eden College
St. Louis
Mo.

THIS SIDE IS EXCLUSIVELY FOR THE ADDRESS.

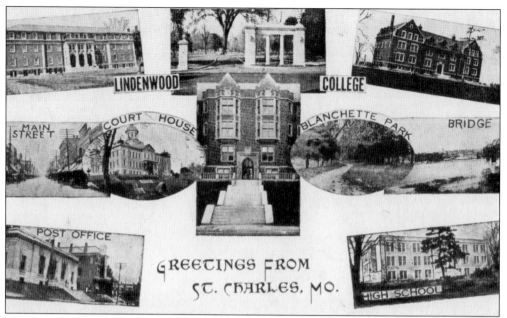

GREETINGS FROM
ST. CHARLES, MO.

Photographic collages of various buildings, businesses, and popular places allowed senders to share visual features of their hometown or towns visited with family and friends. Civic pride was prevalent in the early 20th century. According to the 1939 city directory, St. Charles covered 3.5 square miles, the population was 12,000, and the city slogan was "Pull for St. Charles or Pull Out." The top three manufactured products were shoes, railroad cars, and beer. A total of 1,400 residents enjoyed telephone service. City streets totaled 35 miles, 23 miles of which were paved.

By 1900, a large percentage of St. Charles's population was German—either immigrants or first-generation. St. Charles had two German newspapers, and the German language was taught in some schools. It was common to hear German spoken in homes, businesses, and on the streets. This beautifully embossed postcard is written in German.

American Red Cross
Croix Rouge Américaine
Post-Card

Sailor Mail

Paris France. July 5. 1919
Friend.
in gay paris for a few
Red this is some
but I think it is
a little too fast for
average man. I am
ing a good time and
t to take in the battle-
ds for a few days. Emil

Mr Hellmuth Mie
Terminal Buffe
St. Charles.
Mo.

The American Red Cross provided postal supplies to soldiers in the years during and immediately after World War I. Addressing a postcard to local businessman Hellmuth A. "Red" Meier, owner of the restaurant attached to the streetcar terminal near the Highway Bridge, spread word of this soldier's well-being to friends and neighbors in St. Charles. Meier was an important member of the St. Charles business community. When fire destroyed part of the Highway Bridge woodwork in 1916 and forced the bridge to close, Meier took immediate action. He secured ferry services between St. Charles and St. Louis County until the bridge could be repaired and reopened.

A Woodland Scene

Greetings from
Old St. Charles, Mo.

The City of Substantial Homes
and Friendly People

Acres of undeveloped woodland stood just a few miles from downtown St. Charles. Residents enjoyed a full sampling of the four seasons most years. Summers were extremely hot and humid, and winters were marked by heavy snow, ice, wind, and subzero temperatures.

Three

Boats, Wagons, Trains, Automobiles

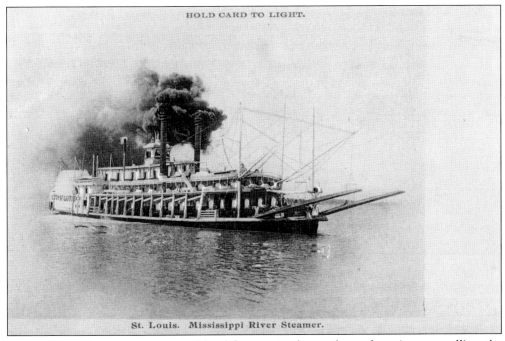

HOLD CARD TO LIGHT.

St. Louis. Mississippi River Steamer.

Capt. Austin Owen spent much of his life as a riverboat pilot and engineer travelling the Mississippi, Ohio, Missouri, and Illinois Rivers before coming to Missouri in 1845. When the Northern Missouri Railroad came to St. Charles in 1856, Owen was contracted to transport people and freight across the Missouri River between St. Charles and St. Louis County.

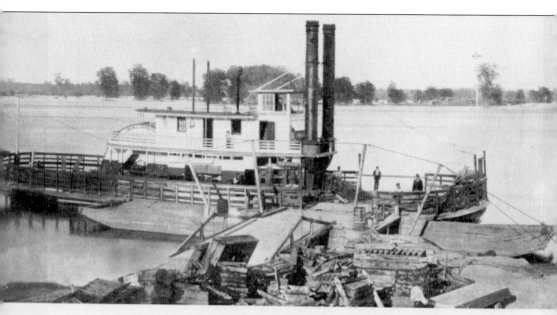

CAPTAIN A. OWEN'S FERRY BOAT, JOHN L. FERGUSON
HIGH WATER, 1883
St. Charles, Mo.,

Capt. Austin Owen's ferry, *John L. Ferguson,* carried Wabash Railroad passengers across the Missouri River while the bridge, which collapsed December 8, 1881, was repaired. Trains from the west stopped at Adams Street in St. Charles, where passengers boarded the ferry. After crossing the river, the passengers boarded another train in St. Louis County. Later, this ferry offered sightseeing tours to the wreck of the steamboat *Montana,* which struck a bridge pier on June 29, 1884, and sank on the east side of the river. Parts of the sunken vessel have been visible in recent years when the water level has been low.

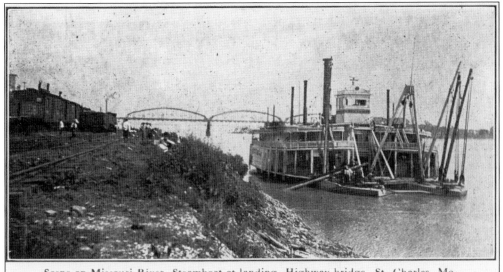

Scene on Missouri River, Steamboat at landing, Highway bridge, St. Charles, Mo.

Life on the river was tough on steamboat vessels. Strong currents, driftwood, sunken trees, and large ice blocks in winter meant the average life of a steamboat was only five years. The steamboat industry declined as railroads expanded after the Civil War.

Steamboats were a familiar sight along the St. Charles riverfront for many years, particularly from spring through fall. They transported passengers, crops, livestock, and the many supplies sold in stores in river towns. The earliest known steamboat landing in St. Charles took place in 1819. Capt. John Nelson piloted his boat, *Independence*, from St. Louis on May 15, and St. Charles was his first stop.

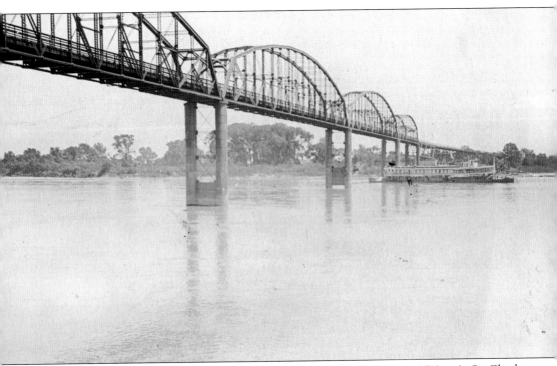

In 1935, ferryboats were again used to transport people across the Missouri River in St. Charles. On June 25, several Wabash train cars broke free near the depot, hitting the bridge and the Galt Hotel on Main Street. The impact compromised the bridge supports, causing a large section of the bridge to fall over Main Street. Several people were injured. Ferries were used until the bridge was repaired. The Galt Hotel building, which today is a restaurant, was also repaired.

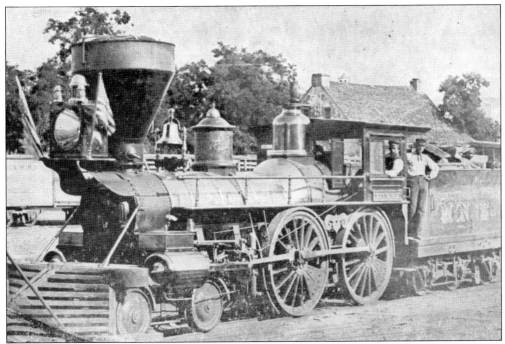

Train service arrived in St. Charles in 1856 and was supplied by the Northern Missouri Railroad. Travel between St. Charles and St. Louis County was time-consuming because there was no railroad bridge. Train passengers and freight were unloaded and ferried by boat across the river, where another train was loaded and service continued. The transfer process took approximately six hours and continued during the Civil War. Shown here in 1856 is the first locomotive in St. Charles.

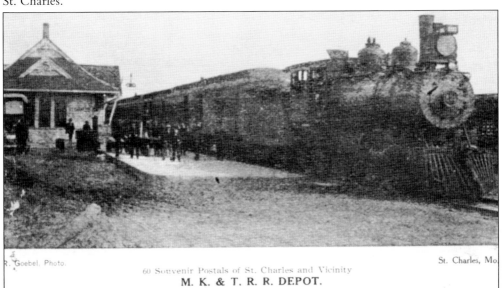

A second railroad, the Missouri, Kansas & Eastern, began service to St. Charles in 1894. St. Charles's location, on the banks of the Missouri River and the edge of the old Louisiana Purchase, made it a busy transportation crossroads.

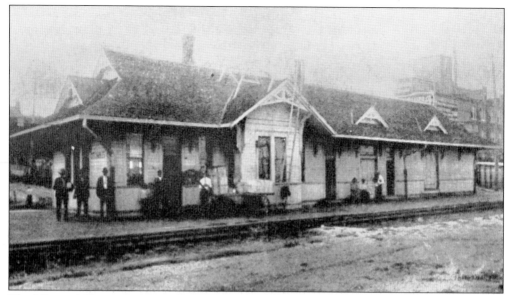

The Missouri–Kansas–Texas Railroad depot was built in 1895 and remained in use until 1958. The ornate details are typical of Railway Gothic architecture. In 1921, a mail messenger with a pouch containing approximately $112,000 was kidnapped at the depot. In 1979, the depot building was relocated to the Missouri riverfront and restored. People hiking and biking along the KATY Trail State Park use it as a rest stop.

Completed in 1904, just in time for the Louisiana Purchase Exhibition, also known as the St. Louis World's Fair, a new bridge across the Missouri River opened for streetcars, wagons, and pedestrians. Costing $400,000, the massive structure operated as a toll bridge until 1932. The St. Louis, St. Charles & Western Electric Railroad Company ran the streetcar line across the Highway Bridge, and later an electric express car began hauling freight between St. Charles and St. Louis County.

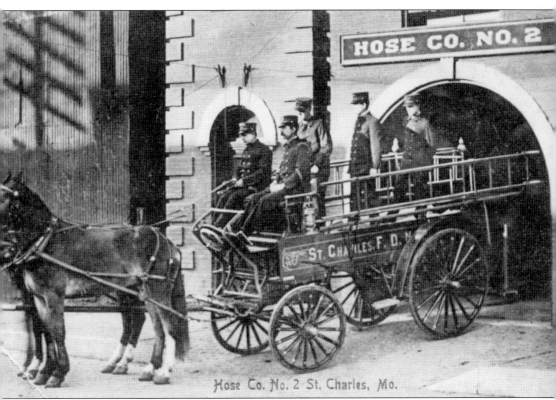

Hose Co. No. 2 St. Charles, Mo.

The Fourth Ward Hook & Ladder Company, Hose Company No. 2, was located in a Frenchtown building constructed about 1880. Frenchtown is a St. Charles neighborhood named for the early-1800s French settlement. Horse-drawn fire equipment seldom arrived in time to save structures from significant damage, but firemen often were able to stop fires from spreading, and that was an improvement over earlier bucket brigades. Fire-alert boxes pinpointing specific areas of town were positioned throughout the city. The first fire engine arrived in St. Charles in 1921. Today, this Second Street building is the Frenchtown Museum.

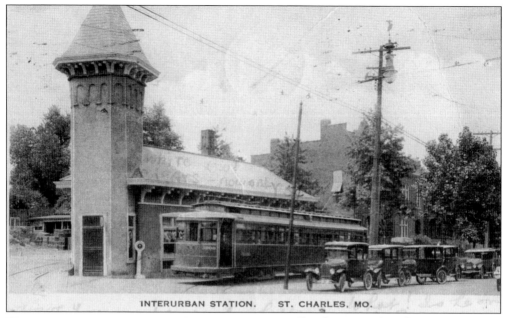

INTERURBAN STATION. ST. CHARLES, MO.

The electric car line from St. Charles to St. Louis County was known as the St. Charles Line. The line ended where the Highway Bridge terminated at Second Street. In February 1913, a terminal building opened at Second and Adams Streets. The terminal was designed to accommodate passengers at the front of the building and freight at the back. There was no turnaround; streetcars had no front or back, they simply reversed direction.

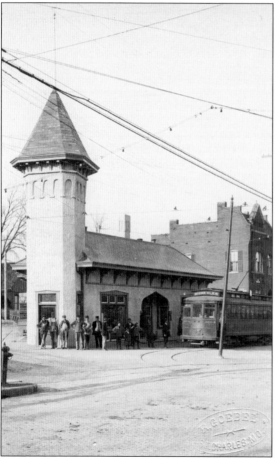

The terminal building was designed with exterior lights, so work could continue before and after daylight hours. Forty lights were mounted around the eaves and roofline, and the building was soon a transportation hub. Those living nearby, however, complained about the noise around the terminal building.

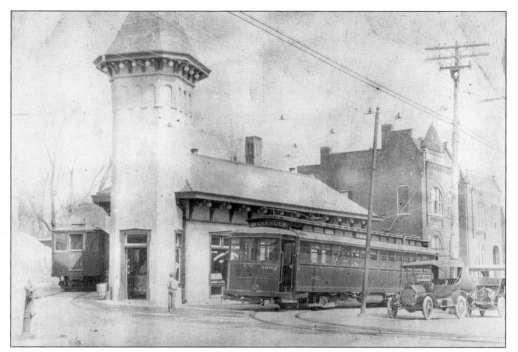

It was not long before St. Charles businessman Hellmuth A. "Red" Meier opened a restaurant to feed hungry travelers. An early-1930s advertisement for the Terminal Café reads, "A place of strong appeal to those who enjoy attractive surroundings. Meals are excellent and well served. Farmers produce fresh foods that add to the tastiness of our meals."

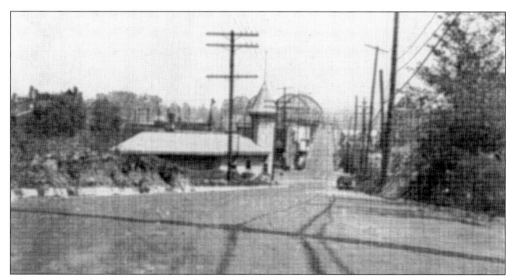

Three types of streetcars eventually used the St. Charles terminal—freight, passenger, and express. Express cars carried passengers and freight. The freight and express cars traveled from St. Charles to downtown St. Louis. Passenger cars traveled to Wellston, a St. Louis streetcar hub where passengers could change to cars bound for other St. Louis locales.

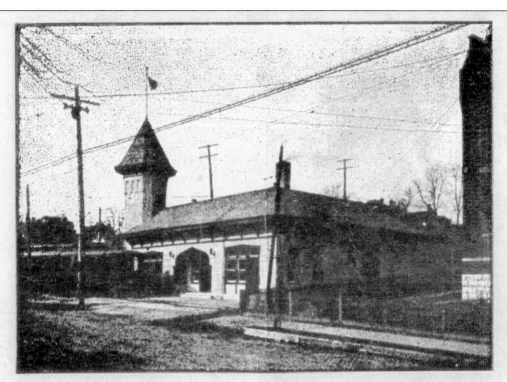

St. Louis-St. Charles Electric Car Station, St. Charles, Mo.

St. Charles was known for many years as the place for quick weddings. Unlike St. Louis, it did not require blood tests and had no three-day waiting period for marriage licenses. In the early 20th century, couples boarded streetcars for St. Charles, where several justices of the peace readily performed weddings. Justice Max J. Frey lived a few yards from the St. Charles terminal building. He became known as the "marrying judge." In 1924, St. Charles issued 955 marriage licenses. Many were performed by Justice Frey.

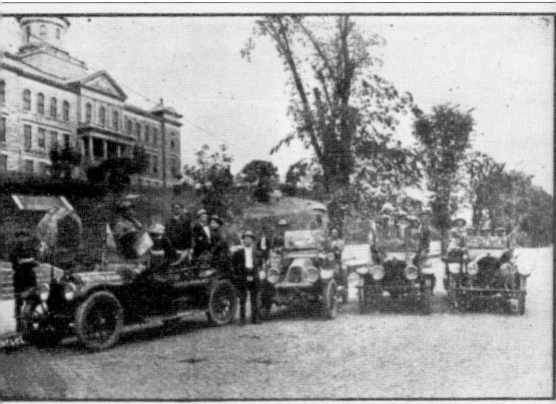

ast to Coast Tourist Party at the Old Boonslick Trail Marker
Second and Jefferson Streets, St. Charles, Mo.
The Starting Point of all the Old Western Trails.

St. Charles was a supply stop for most settlers journeying west. Daniel Boone and his sons settled here in the 1790s, using a trail to reach salt licks west of St. Charles. Settlers, too, began using this trail, known as the Boone's Lick Trail. It continued west to Franklin and on to Independence, Missouri, where it joined the Santa Fe Trail. A 1913 plaque placed at the courthouse by the Daughters of the American Revolution and State of Missouri marks the Boone's Lick Trail starting point. It was popular for early automobile touring parties to begin journeys here, as shown in this image.

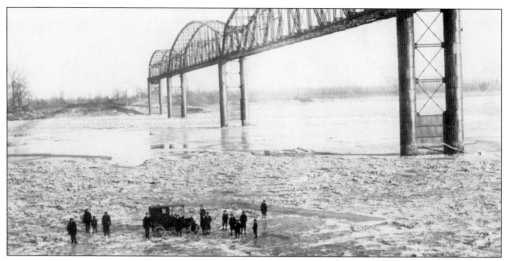

Large ice blocks or floes were frequent along the Missouri River, usually originating from points north. But some St. Charles winters were so cold that the river froze completely, as shown in this image from February 1917. Automobiles, an increasingly popular means of transportation, sometimes found crossing the actual river easier than maneuvering across the bridge. St. Charles had been hit the previous February with a major ice storm that coated trees, streets, and houses with a thick layer of ice.

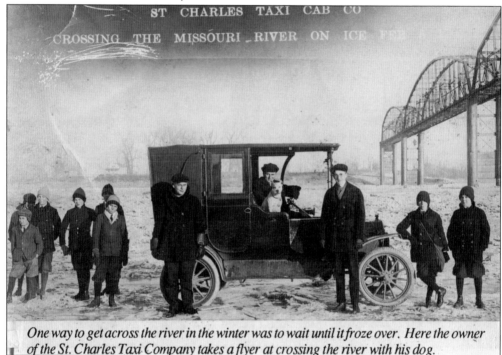

One way to get across the river in the winter was to wait until it froze over. Here the owner of the St. Charles Taxi Company takes a flyer at crossing the river with his dog.

Horses, wagons, and winter sleighs were still popular modes of transportation in 1917, but things were changing. In 1909, only 14 St. Charles residents owned an automobile. The St. Charles Taxi Cab Co. opened, offering residents an option to private ownership and travel by streetcar. In this February 1917 image, a cabbie and his dog venture boldly onto the frozen Missouri River near the Highway Bridge, attracting young onlookers.

Four

PEOPLE AROUND TOWN

Historical Subject.—Daniel Boone's Cabin Built in 1795 and House Built by his son Nathaniel in 1820, both at Femme Osage, St. Charles County, Missouri. Daniel Boone was America's most noted pioneer and backwoodsman. Early day pioneer of North Carolina and Virginia, he was the first settler and practically founder of the State of Kentucky. Among the first settlers of the back country of St. Charles County and of Missouri where he was Commandant and Judge.

Frontiersman Daniel Boone and his sons and their families settled in the St. Charles area in the late 1790s. He served as judge and was instrumental in creating the Boone's Lick Trail. The trail began in St. Charles and was the major road for settlers traveling to points west. The home of Nathan Boone, Daniel's son, has been restored and is part of a living history village in western St. Charles County.

Daniel Boone spent the last two decades of his life in St. Charles County. He was named a commandant/judge and was responsible for settling disputes among nearby residents. He held court under a large tree on his son Nathan's property. The tree was known as the Judgment Tree. It became diseased years later, and efforts to preserve it were unsuccessful.

GOEBEL NEGATIVE BY E. ROBYN ST. CHARLES, MO.
THE JUDGEMENT TREE.
During the Spanish Rule Daniel Boone held court under this tree

Daniel Boone never studied law, but he was appointed a magistrate in southern St. Charles County, where he and his family settled. He was said to be a fair-minded judge and was respected by others living in the area.

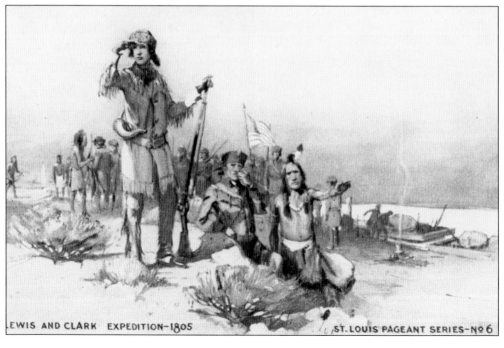

LEWIS AND CLARK EXPEDITION-1805 ST. LOUIS PAGEANT SERIES-N⁰ 6

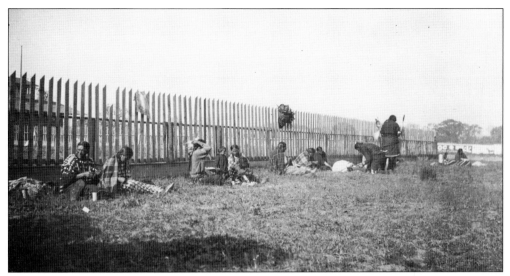

During his expedition with Meriwether Lewis, William Clark became skilled at communicating with Native Americans. When he returned, Pres. Thomas Jefferson appointed him superintendent of Indian affairs for the Louisiana Territory. Clark negotiated treaties with more than a dozen tribes, including the Sioux, who sided against the British after the War of 1812 and ceded land to the United States. A treaty was signed at nearby Portage Des Sioux in 1815. In the 1880s, Sioux tribesmen arrived in St. Charles to see the land that once belonged to their ancestors.

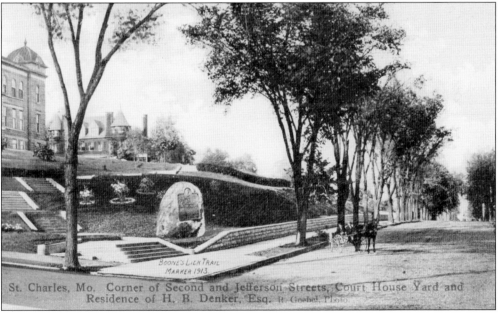

St. Charles, Mo. Corner of Second and Jefferson Streets, Court House Yard and Residence of H. B. Denker, Esq. R Goebel Photo

In 1913, the Daughters of the American Revolution and the State of Missouri placed a commemorative plaque at St. Charles Courthouse honoring Daniel Boone's contribution to westward expansion and marking the point where the Boone's Lick Trail began. Eventually the path of the trail became Interstate 70. Also shown in the background of this image is the town's largest residence of the day, built by Henry B. Denker, a well-known man of business and St. Charles mayor.

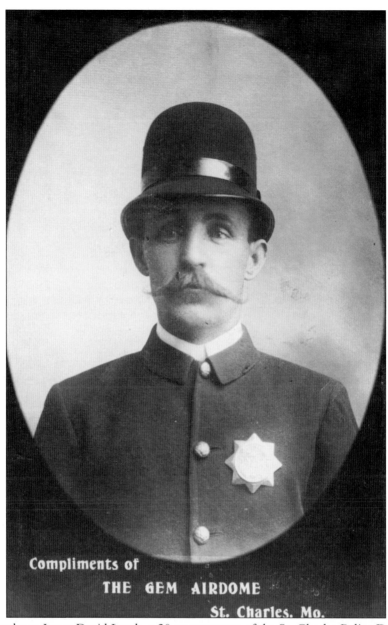

Compliments of

THE GEM AIRDOME

St. Charles, Mo.

Senior Patrolman James David Lamb, a 20-year veteran of the St. Charles Police Department, was shot and killed at the end of his shift on December 6, 1913. Lamb and another patrolman attempted to arrest three gamblers who previously had been asked to leave town. Witnesses said the men had been drinking and displayed guns. Gunfire was exchanged, and the officers were killed, but not before Lamb killed one of the suspects. A posse caught the other two suspects, brothers, 10 miles from St. Charles. After their 1914 trial, they were found guilty and hanged in the city's first double execution. Lamb's brother, police officer Robert Lamb, placed the rope around one perpetrator's neck. The local newspapers covered the case in minute detail, describing the shoot-out and the execution. About 250 people, six of whom were women, witnessed the hangings. The Gem Airdome, an outdoor theater in St. Charles during the early days of motion pictures, printed and distributed this commemorative card.

Sporting a tailored uniform and proper hat, Katherine King worked for many years at St. Charles Military Academy, where her responsibilities included planning menus and preparing meals for the student residents. She was one of only a few women seen daily around campus.

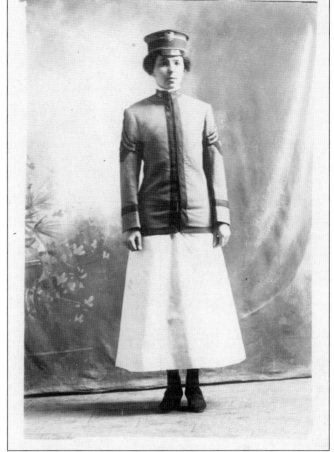

Baseball has been a popular sport in St. Charles for 100 years. Countless children and adults have participated in organized leagues as well as informal neighborhood games over the years. Generations of parents, grandparents, and spectators have cheered their favorite teams to victory during summer competitions in St. Charles.

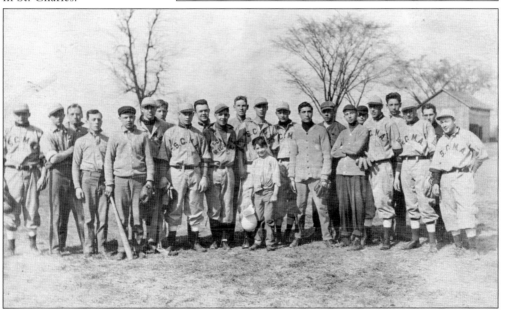

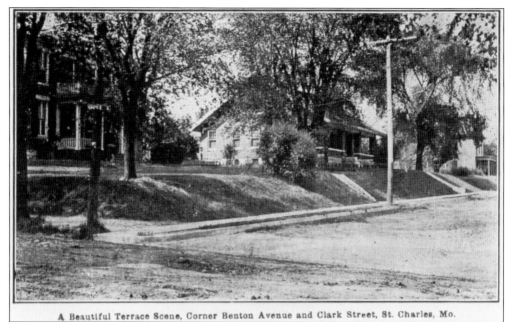

A Beautiful Terrace Scene, Corner Benton Avenue and Clark Street, St. Charles, Mo.

St. Charles's terrain rises into hills from the Missouri riverfront. In some neighborhoods, terraces were used for grading purposes. Done properly with drainage areas, plantings, rocks, or timbers, terracing inhibits soil erosion and allows rainwater to drain properly.

NORTH THIRD STREET, ST. CHARLES, MO.

Utility poles and lines crisscrossed St. Charles neighborhoods in the early part of the 20th century. The city was serviced by multiple railroads, two telephone companies, several banks, multiple mercantile stores and churches, jewelers, hotels, restaurants and bars, and breweries. Life in St. Charles would change rapidly as these girls grew to adulthood. John Gossler, the photographer for this card, worked for Rudolph Goebel for 44 years and then bought the Goebel studio in 1916.

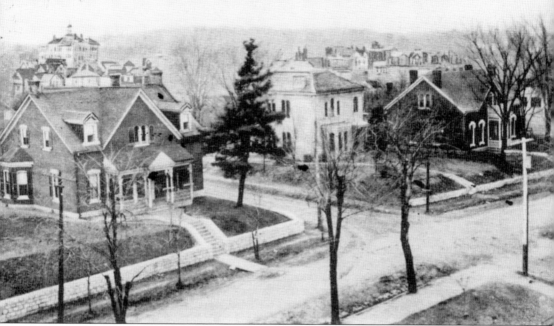

Third & ~~Monroe~~ Sts., St. Charles, Mo.

In the late 1800s and early 1900s, business success in America often translated into spacious, rambling residences. St. Charles was no exception. Businessmen, bankers, and lawyers who worked hard and earned their wealth on Main Street chose open land west of the riverfront for their home sites. During this period, elaborate masonry and carpentry details could be seen on the Gothic and Greek Revival, Italianate, and Queen Anne Victorian houses popular in St. Charles. Many of these homes remain today, having seen generations of families come and go. During a housing shortage after World War II, most of the large, rambling homes were divided into apartments. Today, most have been lovingly restored to their original beauty and again serve as single-family dwellings. Some have been placed in the National Register of Historic Places.

70 Souvenir Postal Cards of St. Charles and Vicinity.

R. Goebel, Photo, 1880. St. Charles, Mo

ST. CHARLES SIAMESE TWINS.

St. Charles, Mo.,

Photographer Rudolph Goebel was seldom seen without a camera. When not in his studio taking portraits, he walked around town, looking for interesting subjects to photograph. Although St. Charles was a bustling river city in the early 20th century, forests could be found just a short distance from Main Street. It was here that Goebel photographed a tree limb that had fused to a different tree, and he used it to create this amusing postcard.

Five

CELEBRATIONS, PARADES, GATHERING SPOTS

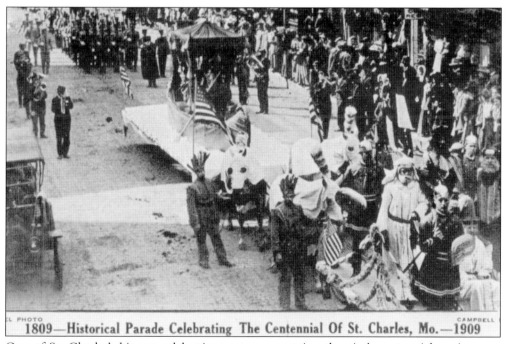

L PHOTO CAMPBELL
1809—Historical Parade Celebrating The Centennial Of St. Charles, Mo.—1909

One of St. Charles's biggest celebrations, commemorating the city's centennial anniversary, took place in 1909 from October 11 to October 16. A parade was held each day, and groups, organizations, and church congregations all participated. Schools canceled classes so the children could march. An estimated 500 children participated in the first day's parade. The city's population at that time was approximately 12,000.

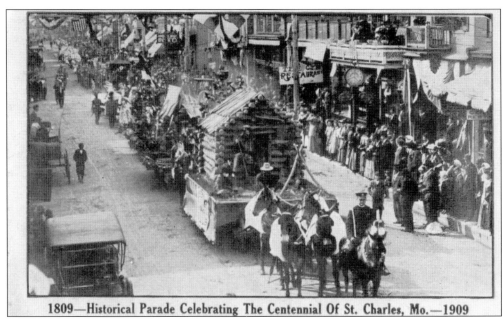

1809—Historical Parade Celebrating The Centennial Of St. Charles, Mo.—1909

St. Charles's centennial celebration was planned for 18 months and included military bands, a Ferris wheel, midway attractions, vaudeville performers, boat races, fireworks, track-and-field events, a horse show and races, clowns, and a baby contest. A special 22-mile automobile parade drew lots of attention, as automobiles were a rare sight on St. Charles's brick streets. Former residents were invited to return for the festivities.

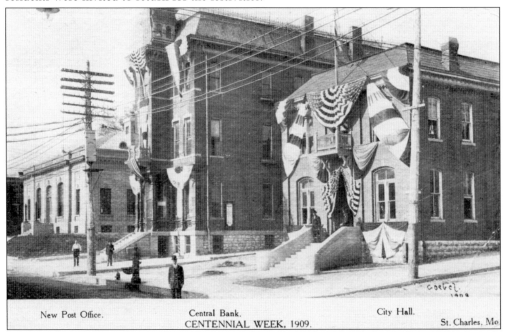

New Post Office.	Central Bank.	City Hall.

CENTENNIAL WEEK, 1909. St. Charles, Mo.

The event's official colors, purple and gold, were seen throughout St. Charles during the centennial celebration, along with patriotic bunting along Main Street. Bunting, banners, and flags decorated horses, buildings, floats, wagons, and automobiles. Special music titled "Daniel Boone March Two-Step" was written for the celebration by E.A. Schubert, a local musician.

St. Charles demonstrated its patriotism in June 1918 by setting a state record for the purchase of Liberty Bonds. The city celebrated the Armistice a bit prematurely on November 7 when false news began to spread about the war's end, but this did not dampen excitement when the real news arrived November 11.

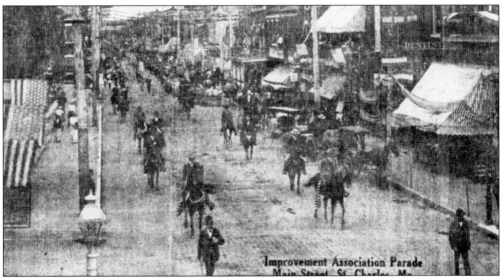

St. Charles residents have for many generations enjoyed parades, whether watching them or participating in them. Independence Day, high school homecoming, and the Christmas Traditions parades are still held on the brick-paved Main Street and throughout town. This photograph shows participants in an Improvement Association Parade held in the early years of the 20th century.

Church bells rang and factory whistles blew when news of the Armistice arrived in St. Charles. World War I was over, and St. Charles residents celebrated. Main Street was the scene of parading, cheering, and dancing as merchants spread the word about the war's end. There would be no more guards on the Wabash Railroad Bridge and no more uniformed home guards.

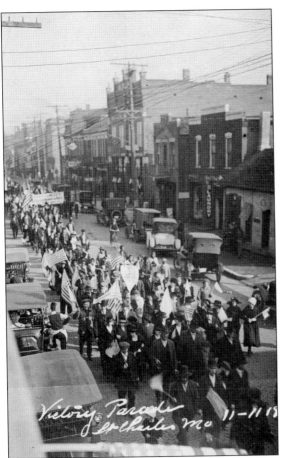

An official Victory Parade was held on Saturday, November 16. Uniformed soldiers and residents of all ages hit the streets, waving American flags and celebrating. Dozens of St. Charles's men had answered the call when asked to serve their country. Crowds had gathered at the train station to bid them farewell. Forty-seven servicemen made the supreme sacrifice and never returned home. Their names are inscribed on a monument on the courthouse grounds.

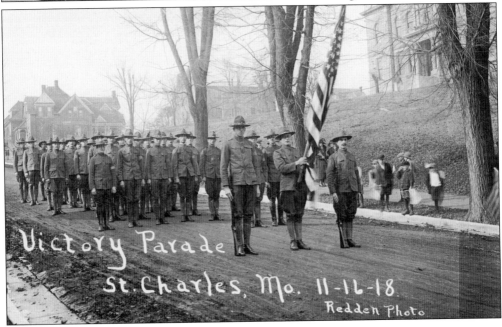

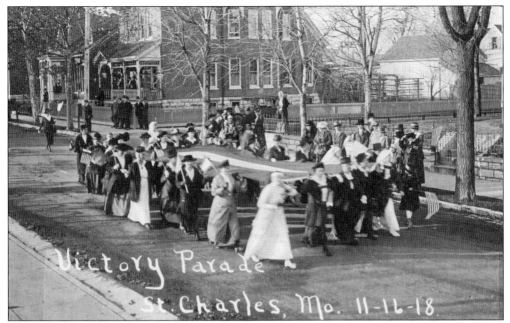

"When the news of Germany's surrender reached St. Charles, the town went wild," said an eyewitness to the celebration. "Businesses closed. Everybody got ready to parade. Never before was there such demonstration. Eight thousand people joined the St. Charles Military Band and the high school band to march up and down the city streets."

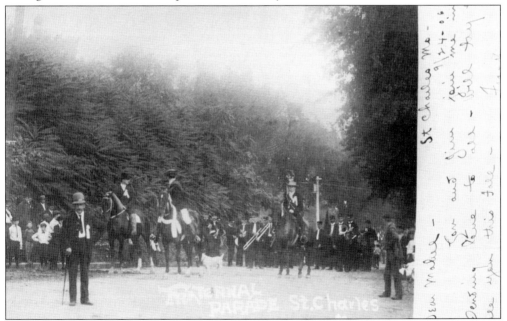

Fraternal organizations were popular throughout the country during the late 1800s and early 1900s. Some were service organizations, and others were social groups. The 1891 *St. Charles City Directory* reports the city had "Secret Societies–a large number." The Odd Fellows, Knights of Pythias, Woodmen of the World, and the Pikers were a few of the groups represented in St. Charles. Members of the various organizations held a fraternal parade in 1906.

60 Souvenir Postal Cards of St. Charles and Vicinity St. Charles, Mo
THE MAMELLE—3 miles north of St. Charles—a favorite resort 75 years ago.

The Missouri and Mississippi Rivers meet north of St. Charles. Native Americans once lived there, and before settlers changed the landscape, two grassy mounds projected from the main bluffs. French settlers nicknamed the mounds Les Mamelles because they resembled breasts. The terrain no longer exists but was a popular gathering spot in the early 1900s. The word *mamelle* can still be found on subdivisions and street names near the area.

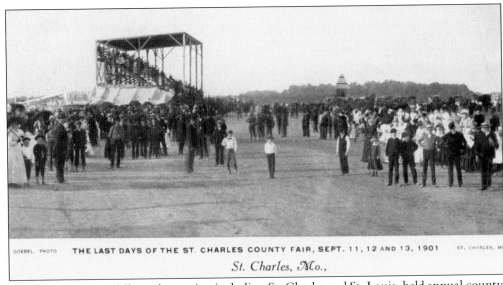

GOEBEL. PHOTO THE LAST DAYS OF THE ST. CHARLES COUNTY FAIR, SEPT. 11, 12 AND 13, 1901 ST. CHARLES, M
St. Charles, Mo.,

A century ago, most Missouri counties, including St. Charles and St. Louis, held annual county fairs. St. Charles's fairgrounds were located in open fields at Randolph and West Pine Streets. Residents looked forward to the annual event. Agriculture and livestock competitions and interesting displays and exhibitions drew many attendees.

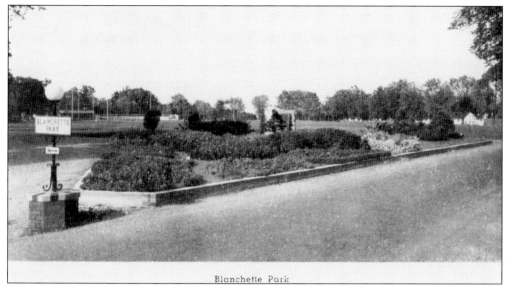

Blanchette Park

Blanchette Park was St. Charles's first city park. The land was acquired in September 1914. The park has remained a popular gathering spot for residents, athletic teams, clubs, and organizations. Included on the grounds is a large sunken area referred to as the Hollow. The area was for many years used as a natural amphitheater. Many St. Charles residents recall hours of sledding fun in the Hollow.

Improvements have been made to Blanchette Park over the years, including the addition of tennis courts, a water park, playground equipment, and baseball diamonds. Blanchette Memorial Hall was built in 1929 to honor the 47 St. Charles County soldiers killed in World War I. The building's dedication on June 22, 1922, was said to be one of the biggest celebrations in St. Charles's history, with an estimated 20,000 people in attendance.

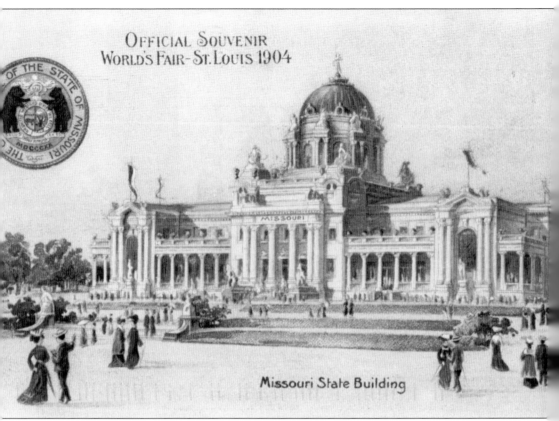

Official Souvenir
World's Fair—St. Louis 1904

Missouri State Building

August 26, 1904, was designated as St. Charles Day at the Louisiana Purchase Exposition, the St. Louis World's Fair, but those living in St. Charles at the time remembered it as the Great Exodus. All business establishments closed, including funeral parlors and saloons. Getting to St. Louis was easy after streetcar service was available over the new Highway Bridge, and trains regularly left the Wabash Station for St. Louis. Special reduced fares for the day made the trip more affordable. "Not even St. Louis can hope to equal the attendance records of St. Charles in point of percentage, when two-thirds of the population of 10,000 persons came down to the World's Fair with a local (Rummels) brass band, flying ribbons, and banners," reported the *St. Louis Post-Dispatch*. " 'The entire suspension of business interests in St. Charles is unprecedented,' said Mayor Paule."

Six

MEDICAL CARE AND
LIVING ASSISTANCE

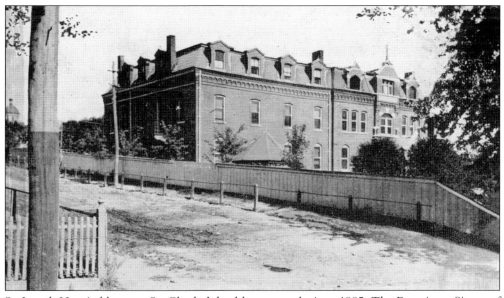

St. Joseph Hospital has met St. Charles's health care needs since 1885. The Franciscan Sisters of Mary (formerly the Sisters of St. Mary) first opened a hospital in a one-and-a-half-story brick French-style home at 305 Chauncey Street. Homeowner Franz Schulte offered it for use as a community hospital provided the sisters ran it. The sisters had cared for his sick infant son, and he wanted to repay their kindness. A larger hospital was built in 1891 near St. Peter Catholic Church and continues today as the SSM St. Joseph Health Center.

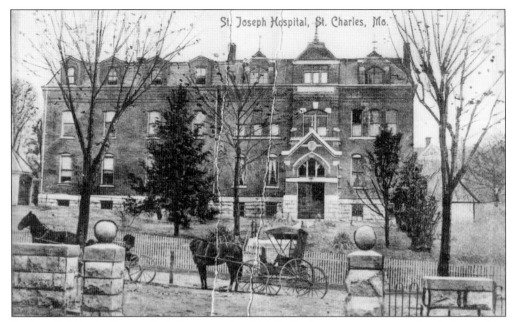

St. Joseph Hospital's new building contained 35 beds. It was more conveniently located to downtown St. Charles. The sisters running the hospital accepted all contributions, including produce, chickens, and donations from community churches and volunteers. A thimble club was formed whose members met regularly to sew items for a bazaar. Bazaar proceeds were given to the hospital to start a children's ward.

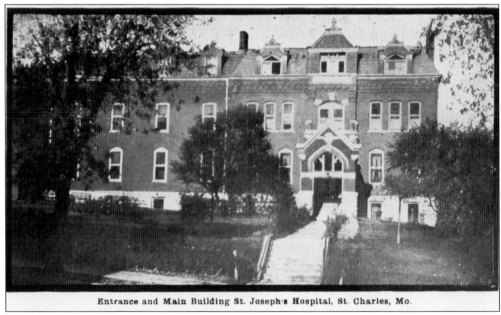

Entrance and Main Building St. Joseph's Hospital, St. Charles, Mo.

In addition to running the hospital, nuns visited patients in their homes and administered medicine as prescribed by doctors. Care was free to those with no money. A group of doctors formed the St. Charles Hospital Medical Association and named Frank Tainter as the first president. Dr. Tainter was a surgeon in World War I and operated the hospital's first X-ray machine.

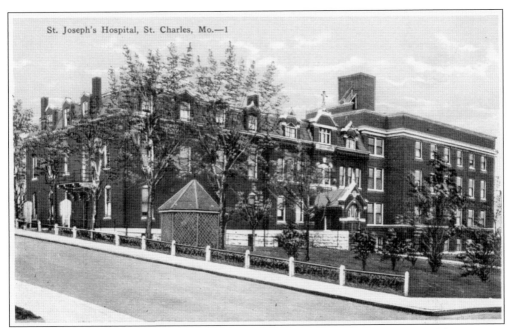

St. Joseph's Hospital, St. Charles, Mo.—1

The growth of St. Joseph Hospital kept pace with that of St. Charles. Building additions were made in 1905, 1924, 1945, and 1960. The level of care provided at the hospital was so good that by 1960, the hospital was serving six surrounding counties. The facility has seen many changes since this photograph was taken. Today, the SSM St. Joseph Health Center has 433 beds and more than 1,500 employees.

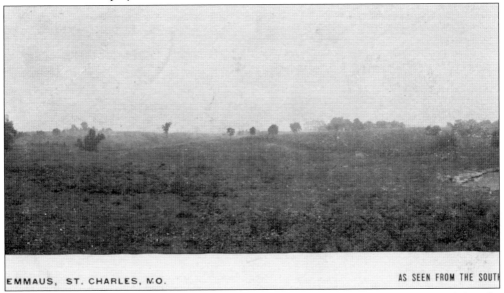

EMMAUS, ST. CHARLES, MO. AS SEEN FROM THE SOUTH

In the days before social welfare programs, religious organizations accepted responsibility for the poor, aged, and physically and mentally challenged individuals. The Emmaus Asylum for Epileptics and the Feeble-Minded was organized in 1892 by the German Evangelical Synod of North America, the predecessor of the Evangelical and Reformed Church of Christ. The next year, a facility for boys and men was opened in the small town of Marthasville in St. Charles County.

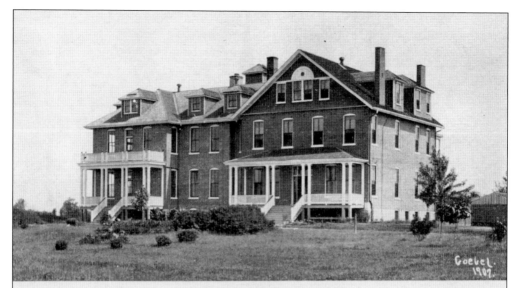

Goebel, Photo. 100 Souvenir Postals of St. Charles and Vicinity St. Charles, M

THE EPILEPTIC AND WEAK MINDED. **EMMAUS** ST. CHARLES, MO. REV. J. W. FRANKENFELD, SUP

In 1897, the Emmaus organization purchased a 110-acre farm near St. Charles's city limits and established living facilities for women in 1901, with an addition built in 1907. Capacity was 55 girls and women, and they lived in a group-home setting and were given tasks to do. As a private organization, Emmaus relied upon contributions.

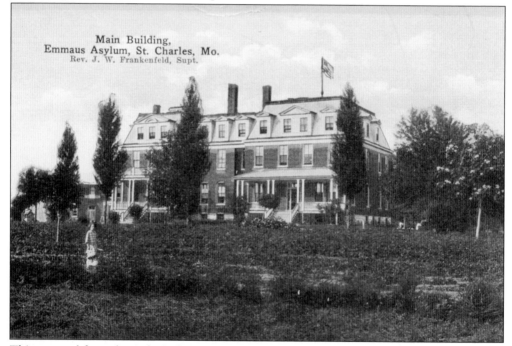

This postcard from the early 20th century shows an artist's rendering of the Emmaus Asylum's main building in a well-landscaped, parklike setting. The card was issued by the private organization's board of directors and features positive, upbeat text promoting the organization and its facilities.

The H. H. Merten Memorial.
Architect, Theo. C. Link.

Emmaus received a large contribution from the estate of a deceased Quincy, Illinois, resident in 1914. A second building was constructed at St. Charles in 1915 with the donated funds. Capacity at the new building was 55 to 60. Both the St. Charles and Marthasville Emmaus facilities had a superintendent and attending physicians to care for the residents.

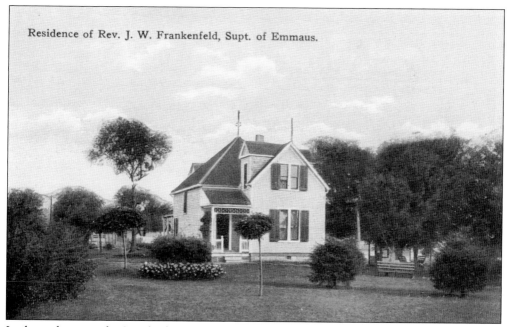

Residence of Rev. J. W. Frankenfeld, Supt. of Emmaus.

In the early years, the St. Charles Emmaus Asylum was run by Rev. J.W. Frankenfeld, who was affiliated with the German Evangelical Synod of North America. The Reverend Frankenfeld lived in a two-story residence on the grounds, near the main building.

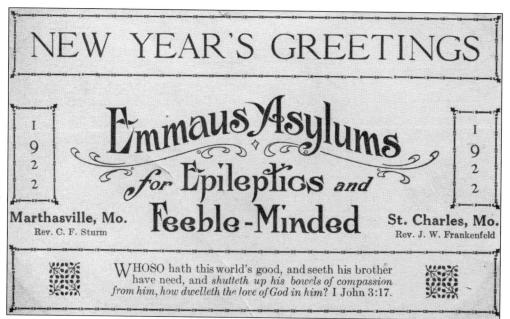

NEW YEAR'S GREETINGS

Emmaus Asylums for Epileptics and Feeble-Minded

1922 — 1922

Marthasville, Mo.
Rev. C. F. Sturm

St. Charles, Mo.
Rev. J. W. Frankenfeld

WHOSO hath this world's good, and seeth his brother have need, and *shutteth up his bowels of compassion from him, how dwelleth the love of God in him?* I John 3:17.

Then, as now, assistance organizations such as Emmaus made solicitations for funds during the end-of-the-year holidays. Postcards were a popular and inexpensive means of communication used by the Emmaus Asylums in the early 1900s.

POST CARD

DEC 31 6 PM

Christmas Greetings

1920

"FOR unto us a child is born, unto us a son is given; and the government shall be upon his shoulder: and his name shall be called Wonderful, Counsellor, Mighty God, Everlasting Father, Prince of Peace."—Isaiah 9, 6.

Emmaus Asylums for Epileptics and Feeble-Minded

The space below is for the Address ONLY

The board of directors for the Emmaus Asylums for Epileptics and Feeble-Minded mailed holiday greetings on simple and inexpensive penny postcards printed with various Bible verses. Early promotional material describes each asylum: "A home for chronic cases of epilepsy and non-violent feeble-mindedness. Special department for senile women."

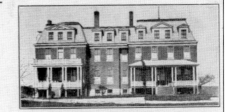

1915 **Herzliche Weihnachts- und Neujahrsgrüsse** 1916

aus Emmaus.

Marthasville, Mo., Hausvater Sturm.

Weihnachtsgruss.

„Das ist gewißlich wahr und ein teuer wertes Wort, daß Christus Jesus kommen ist in die Welt, die Sünder selig zu machen." 1. Tim. 1, 15.

St. Charles, Mo., Hausvater Frankenfeld.

Neujahrslosung.

„Ist Gott für uns, wer mag wider uns sein?" Röm. 8, 31.

„Ist Gott für mich, so trete
Gleich alles wider mich;
So oft ich ruf und bete,
Weicht alles hinter sich."

Thousands of Germans came to St. Charles County in the 1800s after reports published and widely circulated in Germany extolled the beauty and favorable living conditions in Missouri. They were written by German-born Gottfried Duden. Many St. Charles residents spoke and understood German. The Emmaus organization printed solicitation postcards in both English and German. This 1921 card features photographs of both the St. Charles and Marthasville, Missouri, locations as well as German text and scripture quotes.

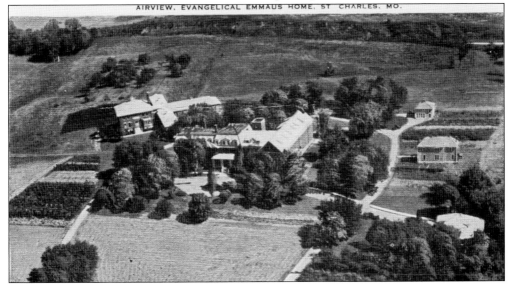

AIRVIEW, EVANGELICAL EMMAUS HOME, ST CHARLES, MO.

The Emmaus organization grew throughout the 20th century and continues work today from the St. Charles office on Randolph Street near Blanchette Park and from a campus in Marthasville. It currently assists and provides homes for 250 special-needs individuals. It is a private, not-for-profit organization affiliated with the United Church of Christ Council of Health and Human Service Ministries.

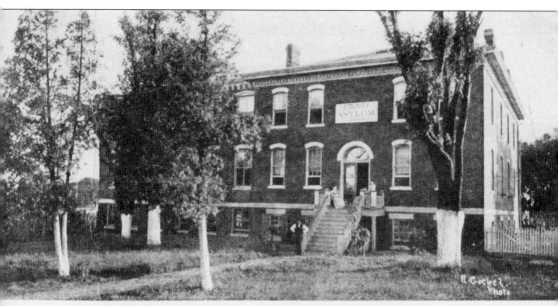

Goebel Photo, St. Charles, Mo COUNTY ASYLUM

Before the days of retirement villas, nursing homes, and assisted living and extended care facilities, elderly residents either lived with family members or moved into the county's home for the aged. In the early 20th century, there were no special diets, recreation, or exercise facilities, no shuttle busses, and no social outings for the elderly residents.

Seven

Educational Excellence

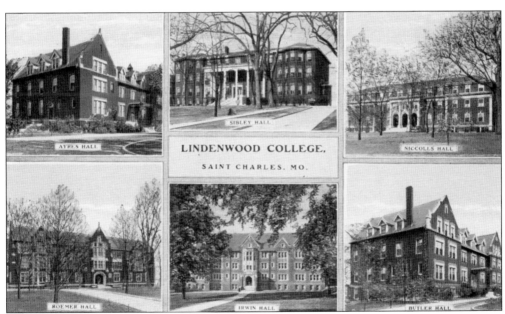

The Linden Wood School for Girls began in 1827 at Mary Easton Sibley's father's house on Main Street. Later, she and her husband George purchased land near the outskirts of St. Charles and constructed a log school building. The school is the second-oldest institution of higher education west of the Mississippi River and evolved to become Lindenwood College, later Lindenwood University.

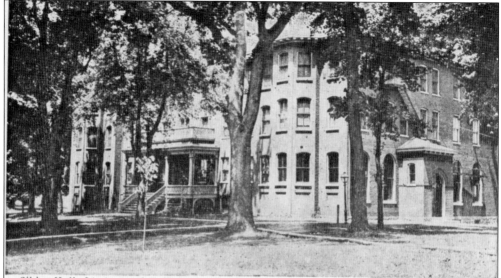

Sibley Hall, Lindenwood College, St. Charles, Mo., first brick building, center of new buildings of present college. Historically Lindenwood is the first protestant girls college of the West Established 1827

Sibley Hall, originally Lindenwood Hall, was the log school constructed on the grounds of the Linden Wood School for Girls in 1856. Listed in the National Register of Historic Places, this later brick building bears the same name as the log school and is still in use as a dormitory. An advertisement in the 1891 *St. Charles City Directory* notes that the school is "under the care of the Synod of Missouri."

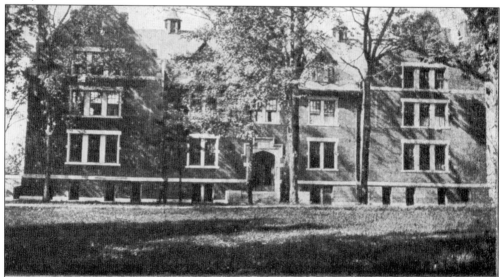

Ayres Hall, Lindenwood College, St. Charles, Mo., First constructed of many new buildings of the present college. Historically Lindenwood is the first protestant girls college of the West

Lindenwood College grew rapidly. Enrollment in 1906 exceeded 100 girls, and by then Sibley Hall was overcrowded. College president George Ayres took action and contacted philanthropist Andrew Carnegie, who agreed to donate $10,000 if Ayres raised another $30,000. Jubilee Hall was constructed and renamed in honor of Dr. Ayres in 1927. Ayres Hall, still in use, housed the first 15 male students when the college became coeducational in 1969.

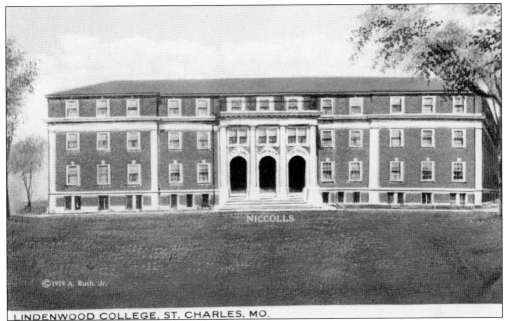

LINDENWOOD COLLEGE, ST. CHARLES, MO.

In the years before World War I, additional dormitory space was needed. Niccolls Hall was built in 1916 and named in memory of Samuel Jack Niccolls in 1917. Niccolls was pastor at St. Louis's Second Presbyterian Church and a member of the Lindenwood Board of Directors. The school has a long affiliation with the Presbyterian Church. Today, Niccolls Hall is used as a women's dormitory.

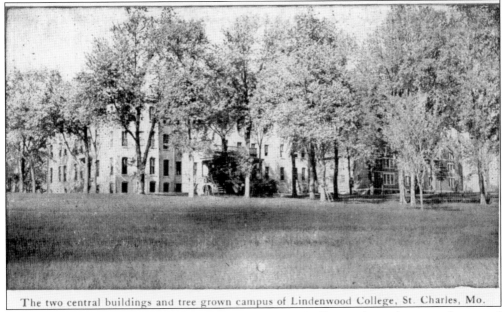

The two central buildings and tree grown campus of Lindenwood College, St. Charles, Mo.

Today, Lindenwood University has 17,000 students and offers undergraduate, graduate, and doctoral programs at the main campus, satellite locations, and online. Students from more than 90 countries attend.

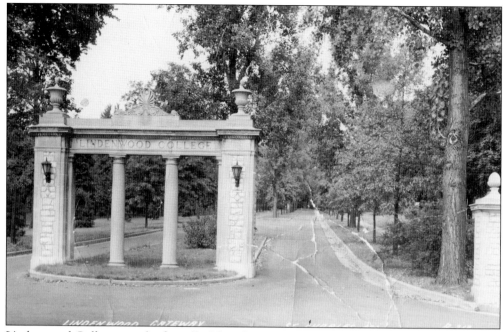

Lindenwood College was the first all-girls college west of the Mississippi River. The elevation of the land on which it was built was the highest in St. Charles. In about 1920, students and alumni donated funds to construct an entrance gateway to the campus from Kingshighway. It was named Alumnae Gate until the 1970s, and then King's Gate, but the original name was restored recently.

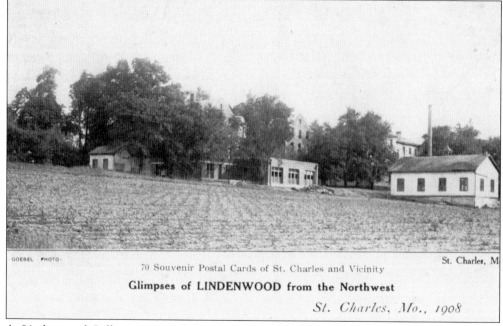

GOEBEL PHOTO St. Charles, M

70 Souvenir Postal Cards of St. Charles and Vicinity

Glimpses of LINDENWOOD from the Northwest

St. Charles, Mo., 1908

As Lindenwood College grew, so did the need for student housing, classroom space, and storage facilities. Additional buildings were constructed to meet those needs. This view shows the northwest section of the Lindenwood campus in the early 20th century.

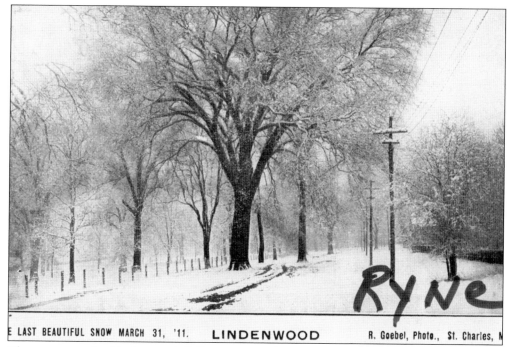

E LAST BEAUTIFUL SNOW MARCH 31, '11. **LINDENWOOD** R. Goebel, Photo., St. Charles, M

Then, as now, the Lindenwood College campus features green space. In 1911, a late-March snowstorm provided local photographer Rudolph Goebel the opportunity to capture the campus's beauty in winter. Utility poles were already in place at that time.

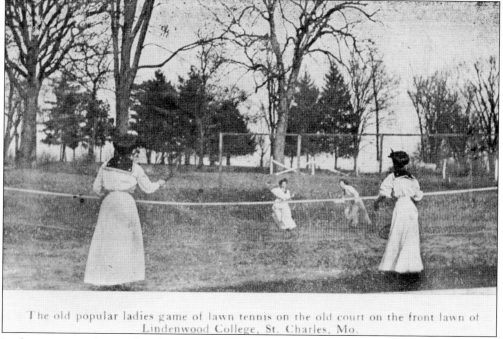

The old popular ladies game of lawn tennis on the old court on the front lawn of Lindenwood College, St. Charles, Mo.

In days past, tennis was played on a grass court and was called lawn tennis. Women wore long skirts, long sleeves, and corsets. Moving, it turns out, was curtailed in sports; it was thought to cause fainting.

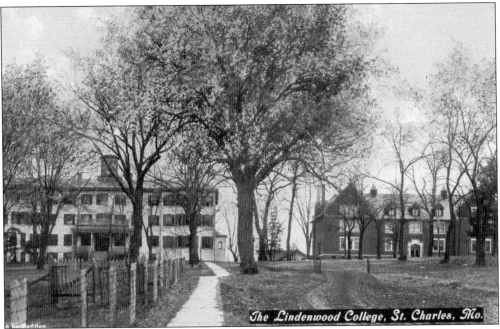

An early-20th-century advertisement describes Lindenwood College as "The Wellesley of the West." A later advertisement in a St. Charles city directory describes it as "One of the Famous American Colleges for Young Women in our own St. Charles, Mo."

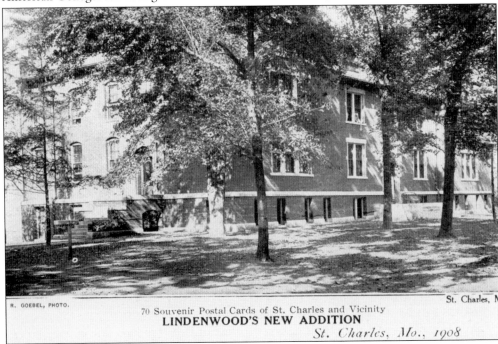

The Reverend Addison Van Court Schenck was president of Lindenwood Female College from 1856 until 1862. It was during his term that Sibley Hall was built. At that time, military education was popular for the education of well-to-do young men. Schenck resigned from Lindenwood to work with his brother at nearby St. Charles Military College.

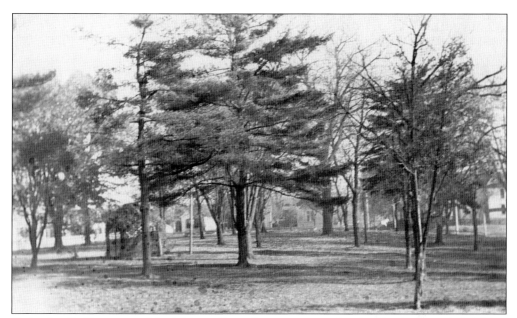

Catherine Collier accomplished things. She and two sons moved to St. Charles from Philadelphia in 1820 after her husband died. She bought two cows and started a dairy. She organized a Methodist church. And in 1835, she and her son George started St. Charles College. It later became St. Charles Military College, then Academy, educating boys until it closed in 1915.

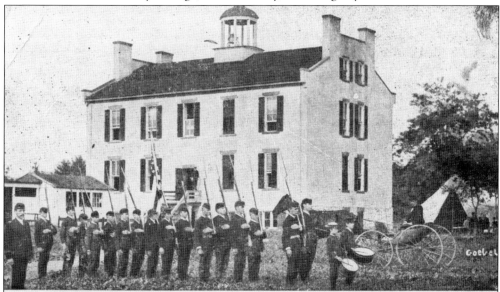

Historical Subject—Old St. Charles College, First boys school in the Mississippi Valley or West of the Mississippi River. Founded 1835.

St. Charles College, located on Third Street, was the first chartered boys' school west of the Mississippi River. The college closed during the Civil War, and the building was used by Lt. Col. Arnold Krekel as a hospital for injured Union soldiers. The basement was used as a Confederate prison. The college reopened soon after the Civil War ended and was for a time located on Clay Street (now First Capitol Drive). From 1901 until 1915, the college was at Third and Jefferson Streets. The teacher–student ratio was 1 to 15.

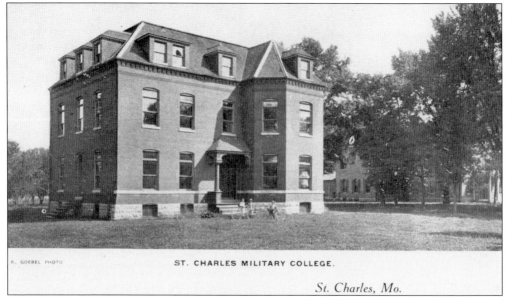

R. GOEBEL PHOTO
ST. CHARLES MILITARY COLLEGE.

St. Charles, Mo.

A 1909 print article describes St. Charles Military College: "Under military system and discipline, the body of the young men and boys is developed in size, health, form, and movement. A scientific course of physical training is maintained by which every muscle of the body is exercised and developed; and by breathing exercises, the lungs and vocal organs are strengthened."

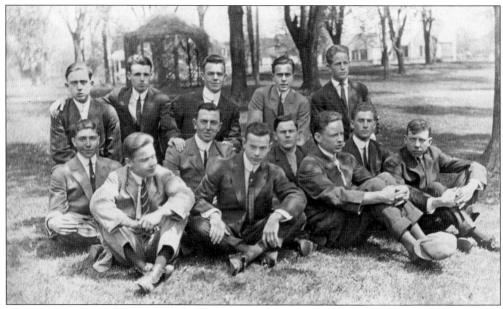

The article continues: "With this training, the cadets learn many of the most useful lessons of life: such as to be neat, exact, thorough, prompt, respectful, obedient, and systematic. The development of the body and the cultivation of good habits have much to do with the mental and moral improvement of the cadets. And this leads up to the attainment of the aim of this institution, to make true and useful men by cultivating all the good in each individual."

94

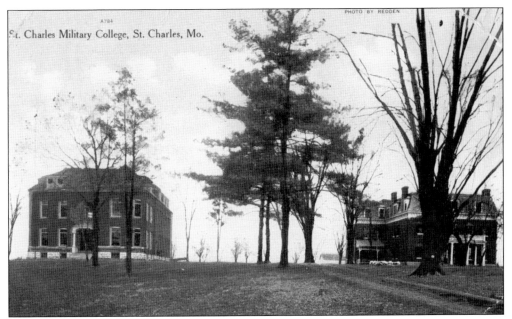

Today, St. Charles High School is located on the site formerly occupied by the St. Charles Military College, at Kingshighway and Waverly Streets.

St. Charles Military College, St. Charles, Mo.

When St. Charles's only high school, Jefferson High School, burned to the ground in 1918, items saved from the building were moved to the vacant St. Charles Military Academy buildings. Classes were conducted there until a new high school could be built.

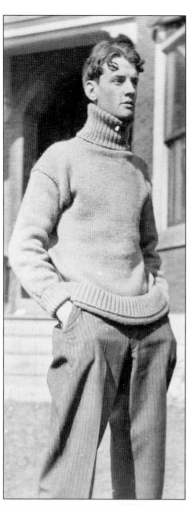

An unidentified student out of uniform has stopped long enough to pose for Rudolph Goebel. The pleated pants and turtleneck sweater he wear give him a classic casual look similar to styles worn today.

Physical training at St. Charles Military Academy, as it was known in the early 20th century, included playing football. The period uniform consisted of a turtleneck shirt, knee-length pants, and tall socks.

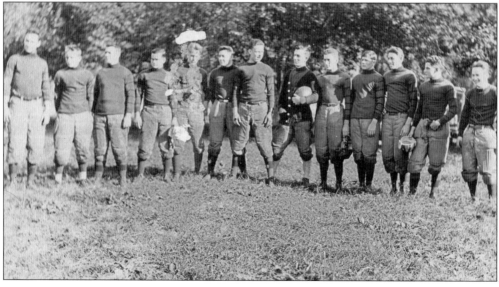

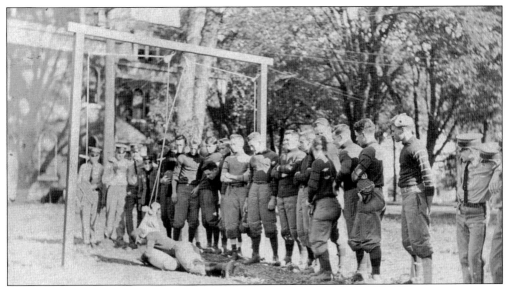

Football practice then, as now, included learning offensive and defensive plays and practicing maneuvers, often using special equipment. Uniformed cadets supervised training that built strength and agility, which improved performance but also helped to minimize injuries.

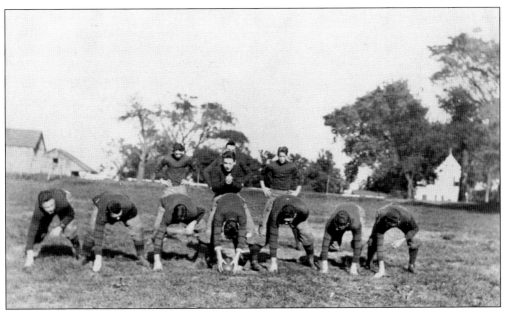

The military academy's football practices and scrimmages were held in a pasture. Maneuvers, positions, and plays from a century back look similar to those seen today. Helmets and nose guards were made of leather. The academy's strategic goals were to develop the physical as well as academic abilities of the cadets.

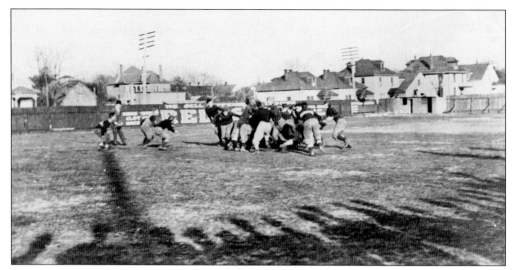

Then, as now, sponsorships and advertising were part of the business of football. A painted wooden sign promoting local wares can be seen behind the crush of players. A coach stands to the left, anticipating Bear Bryant, in suit, tie, and hat. The shadows of spectators can be seen near the bottom of the image.

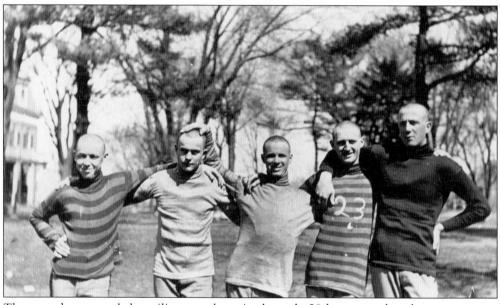

They may have attended a military academy in the early 20th century, but these young men still enjoyed playing football. Here, all sport close-cropped haircuts, and football jerseys are the day's raiment. Playwright and author Rupert Hughes, brother of inventor and entrepreneur Howard Hughes Sr. and uncle of famous aviator and film director Howard Hughes Jr., was an alumnus of St. Charles Military Academy.

Students at St. Charles Military Academy wore uniforms and practiced various military drills each day, including capturing and disarming an opponent. They were frequently seen marching in cadence around St. Charles. The academy's last school reunion was held in St. Charles in 1957, with 50 former students and faculty members in attendance.

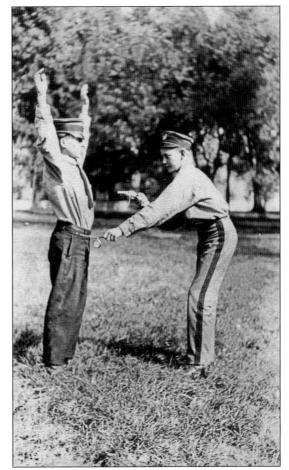

Baseball's popularity quickly spread throughout the country in the early years of the 20th century. Faculty at the St. Charles Military Academy recognized student interest and organized a baseball team, outfitting members in matching uniforms and caps.

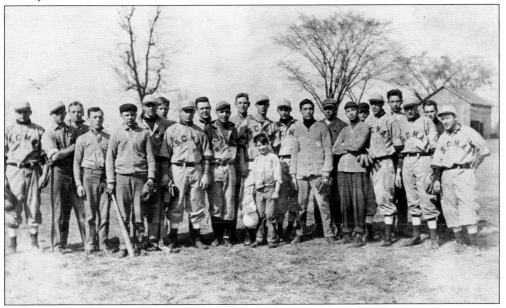

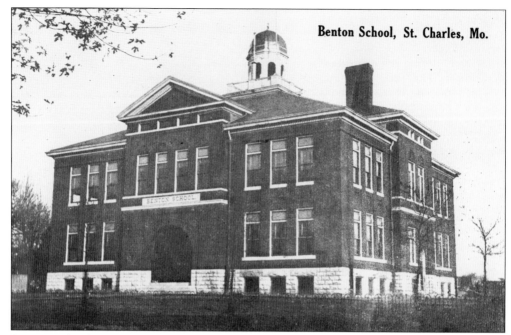

Benton School, St. Charles, Mo.

Benton School on Sixth Street opened in 1896 and operated continuously until 2007. At that time, students moved to other city elementary schools. The building was remodeled as the Benton Administrative Center, headquarters for the City of St. Charles School District. Generations of children remember walking to and from the school. A 1916 city directory reported that Benton had eight teachers and one principal, the largest faculty in the district.

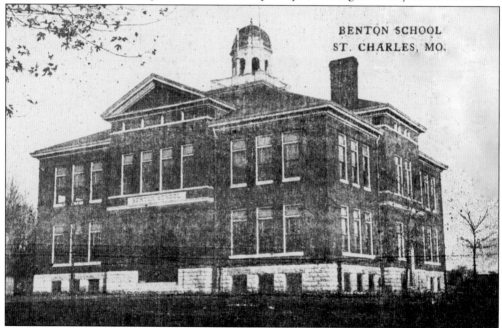

BENTON SCHOOL
ST. CHARLES, MO.

In 2009, the administrative offices of the City of St. Charles School District were located in the old Benton School building. The district, which comprises more than 5,200 students, oversees six elementary schools, two middle school, two high schools, and a vocational training school.

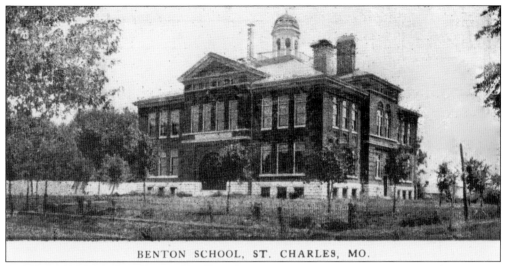

BENTON SCHOOL, ST. CHARLES, MO.

If these walls could talk. Before the days of no. 2 pencils, computer-assisted educational enhancement programs, and Smart Boards, Benton School elementary students sat on wood seats, ciphered, and used bottles of ink to practice handwriting skills. Teaching and learning styles may have changed, but those who work in this building have the same calling as teachers from the 1890s: to educate and enlighten young minds.

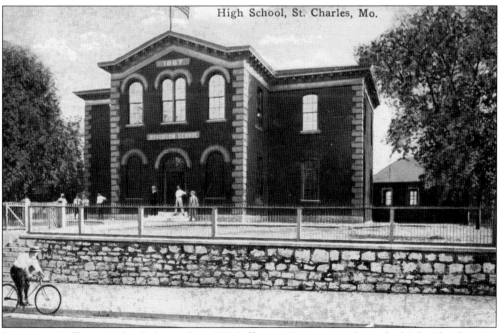

High School, St. Charles, Mo.

For years, Jefferson School, located at 327 Jefferson Street, was the only high school in St. Charles. The school was built in 1867. The 1916 city directory indicated that Jefferson School had five teachers and one principal. In the 1900s, school plays and commencement ceremonies took place at the Opera House on Main Street.

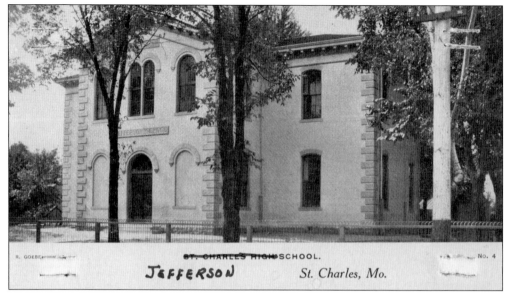

R. GOEBE... ST. CHARLES HIGH SCHOOL. ...NO. 4
JEFFERSON *St. Charles, Mo.*

Jefferson High School existed at a time when earning a high school diploma was a major accomplishment. Few St. Charles children continued formal education beyond their teens. Many students enrolled only through eighth grade. The American Car Foundry hired employees as young as 14, and many families needed the income.

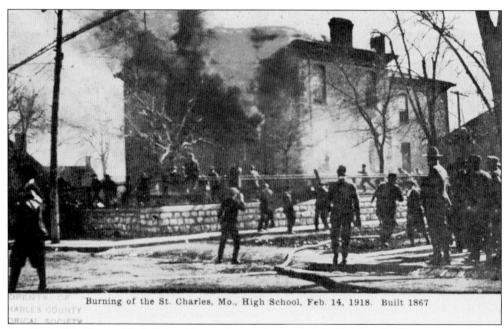

Burning of the St. Charles, Mo., High School, Feb. 14, 1918. Built 1867

St. Charles's Jefferson High School burned on February 14, 1918. The fire began around noon on a school day. St. Charles's two fire companies responded, but low water pressure and strong winds hindered efforts to extinguish the flames. Teachers and students moved library books and other school equipment to safety before the building was engulfed in flames. No one was injured, and the fire did not spread.

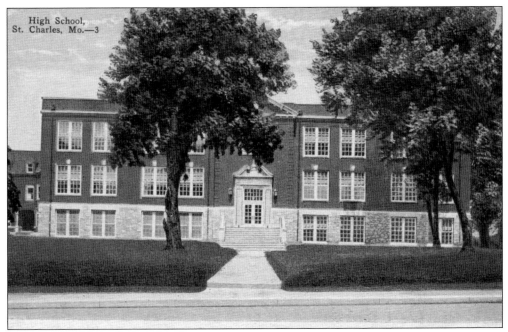

A new high school building was constructed at Kingshighway and Waverly Streets. The school was named St. Charles High School. Educational instruction continued here until August 11, 1995, when fire destroyed the facility. The school was rebuilt on the same site.

storical Subject:—The old Sacred Heart Convent. founded 1818 by Mother Duchesne. First establish-nt Sacred Heart teaching order in America, oldest hool West of Mississippi River. Centenial in 1918. iginal log house followed 1828 by brick house at ht of picture, center is second Catholic church re-

much enlarged. Center is oratory of Mother Duchesr

Mother Duchesne was born in Grenoble, France, August 29, 17 and laid to rest in 1852. The oratory where her remains repose the convent grounds has become a shrine much visited by those w venerate her saintly virtues. In the rituals of the church she I been canonized and beatified.

It was 1818. Missouri was not yet a state but part of the vast Missouri Territory. St. Charles was a small settlement of French immigrants and Native Americans on the low hills rising from the Missouri riverfront. French-born Mother Rose-Philippine Duchesne and four other French-speaking nuns affiliated with the Sacred Heart Order were sent to St. Charles to start a school.

103

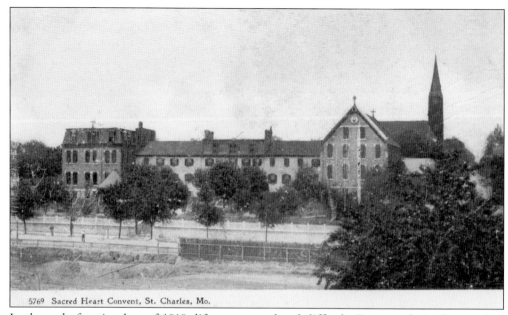

5769 Sacred Heart Convent, St. Charles, Mo.

In the early frontier days of 1818, life was rugged and difficult. Few people in the area had money, thus nuns accepted food, wood, or other commodities as payment for educational instruction. At times, success and survival were uncertain, but the nuns persevered in the tiny log building near the river. Years passed, and both the order and the school thrived.

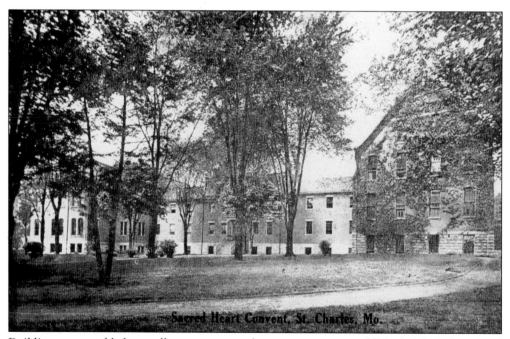

Sacred Heart Convent, St. Charles, Mo.

Buildings were added, enrollment grew, and a convent was established. The educational excellence and outstanding reputation of Sacred Heart Academy continue today. Times changed, and grades 9 through 12 were discontinued. In 1972, male students were admitted for the first time.

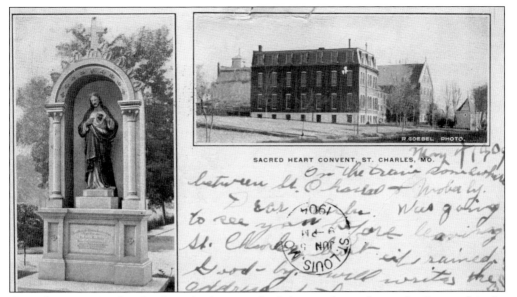

SACRED HEART CONVENT, ST. CHARLES, MO.

Over the years, Mother Duchesne's virtues and mission work to educate the "savages" in St. Charles were recognized by the Catholic Church, and she was venerated, beatified, and in 1988, canonized. Sites surrounding the Sacred Heart Convent have become much-visited shrines.

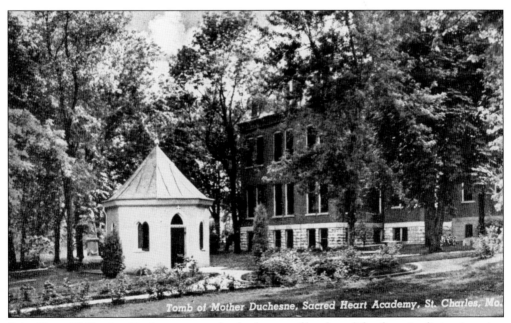

Tomb of Mother Duchesne, Sacred Heart Academy, St. Charles, Mo.

Saint Rose-Philippine Duchesne spent the final years of her long life of service living in a tiny room at the St. Charles convent. It is said that much of her time was spent in prayer. She is buried on the grounds.

The unknown artist of these postcard illustrations had a sense of humor. Portrayed here are classroom scenes from a bygone era. One features all dogs, including the male instructor. The other features all cats, including the schoolteacher. All animals wear clothing styles popular at the turn of the 20th century. One student sports a dunce hat, used a century ago to punish unruly or rude behavior. The illustrations are said to portray St. Charles classrooms.

Eight

HOUSES OF WORSHIP

BORROMEO CHURCH, ST. CHARLES, MO.

St. Charles Borromeo Catholic Church began in a vertical post structure in 1791 near Main Street. St. Charles was a small, rugged frontier town located near the Missouri River. The church was named for San Carlos Borromeo, the 14th-century archbishop of Milan and patron saint of Spain's King Charles III. At that time, St. Charles was under Spanish control.

Some of the members of the Lewis and Clark Expedition were said to have worshipped at St. Charles Borromeo Catholic Church. In 1821, Missouri had achieved statehood, and the parish moved to a larger building at Second and Decatur Streets by 1828. In 1869, the third church facility was built. Generations of St. Charles residents worshipped here.

On July 7, 1915, a tornado hit St. Charles, damaging homes, buildings, trees, and property. There were no injuries, but the stone sanctuary of St. Charles Borromeo Catholic Church, the third-oldest parish in the St. Louis Archdiocese, was destroyed.

When the 1915 tornado passed, only the clock tower of St. Charles Borromeo Catholic Church remained standing. The chancel area was left with no roof or walls. Supports and decorative wood detailing from inside the sanctuary littered the area like broken matchsticks.

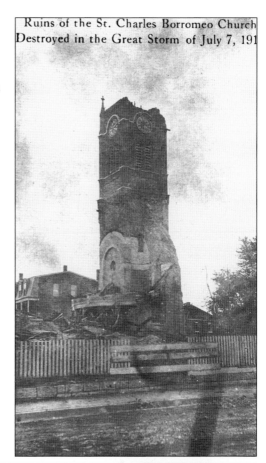

Ruins of the St. Charles Borromeo Church Destroyed in the Great Storm of July 7, 191

Word spread that the storm had destroyed St. Charles Borromeo Catholic Church. Stunned parishioners and neighbors came to the site to survey the damage, thankful that no one was injured or killed.

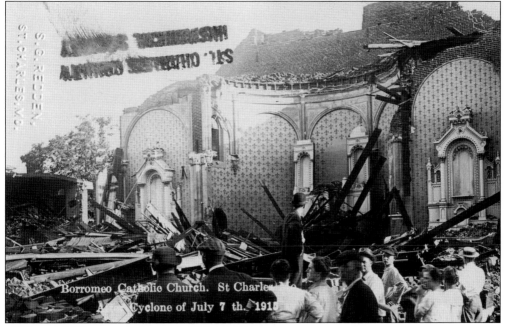

Borromeo Catholic Church. St Charles Mo Cyclone of July 7 th. 1915

109

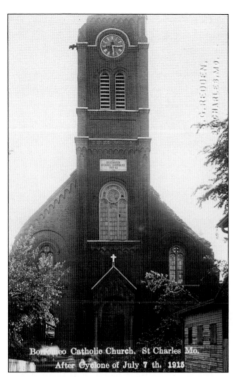

Borromeo Catholic Church, St Charles Mo.
After Cyclone of July 7 th. 1915

After the initial shock of seeing their beloved sanctuary reduced to rubble, the Borromeo church community decided to salvage what they could and begin rebuilding on the site immediately.

Plans were drawn and approved for a large new structure reminiscent of churches found in Europe. Construction crews and artisans went to work crafting a replacement house of worship. The structure that took shape towered over nearby residences and businesses.

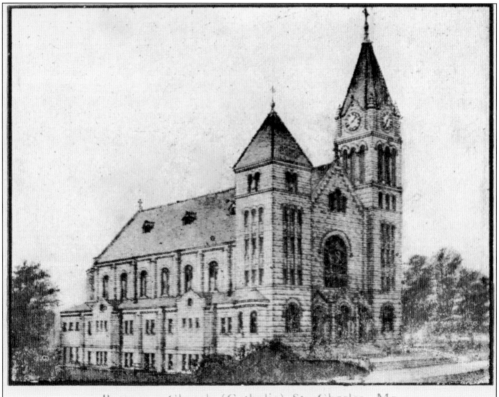

Borromeo Church (Catholic) St. Charles, Mo.

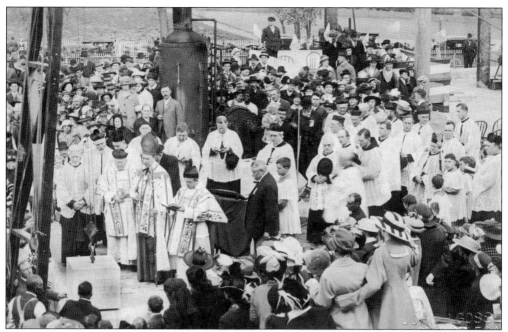

Spring arrived in St. Charles. On April 16, 1916, only nine months after the destructive storm hit, church members held a celebration ceremony as the cornerstone was laid for the new sanctuary. Approximately 5,000 people attended. The church continues today at this location.

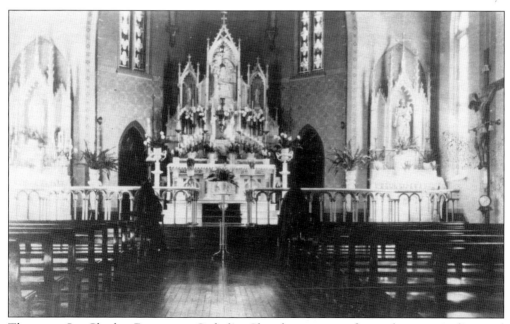

The new St. Charles Borromeo Catholic Church sanctuary featured ornate styling and intricate detail. The church has been an important part of the lives of St. Charles families for many generations.

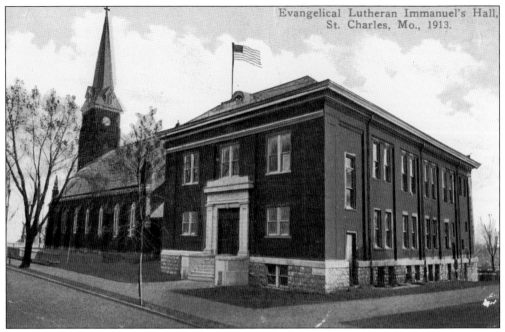

Evangelical Lutheran Immanuel's Hall, St. Charles, Mo., 1913.

Gottfried Duden came to central Missouri and liked what he saw. In the 1820s, he wrote prolifically about the area's beauty and sent descriptive letters back to Germany. Word spread about Missouri's similarity to the German countryside. Thousands of Germans immigrated to the area. The German population was large enough in St. Charles to support several German-language churches and newspapers, including the German Lutheran church today known as Immanuel Lutheran.

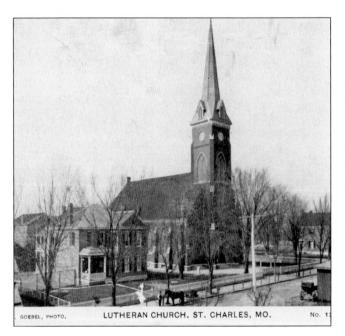

GOEBEL, PHOTO. LUTHERAN CHURCH, ST. CHARLES, MO. No. 1

The German Evangelical Lutheran Immanuel Congregation of St. Charles, St. Charles County, Missouri, and Vicinity began in 1847 when members of another church decided to form a new and separate congregation. A structure was built in 1849 at Sixth and Jefferson Streets. The congregation grew, and in 1867, a larger Gothic-style church designed by German-born Johann Heinrich Stumberg was constructed. Stumberg designed several churches in St. Charles. The "silver-tongued" bells were cast from silver coins donated by church members.

112

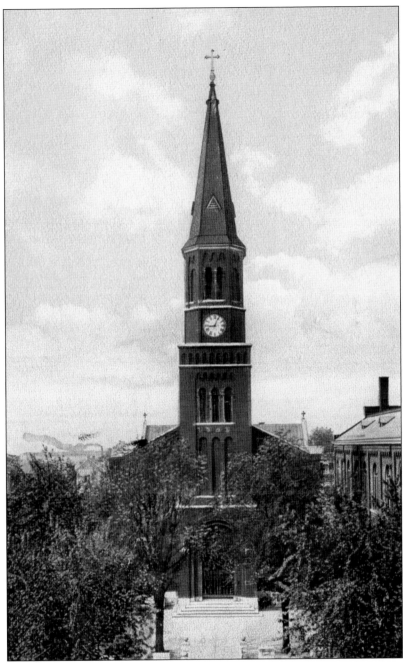

Gottfried Duden wrote and published extensive praises of Missouri in a report titled *Report on a Journey to the Western States of North America*. It was published in Eberfeld, Prussia, in 1829, and 1,500 copies were distributed; an influx of German settlers arrived in the 1830s and 1840s. Many immigrants affiliated with St. Charles Borromeo Catholic Church, which was predominantly French. In the 1840s, the German Catholics formed the St. Peter German Catholic Church and built a parish on Clay Street between Second and Third Streets. Then, in 1861, the building was destroyed in a storm. Johann Heinrich Stumberg, architect of several other St. Charles churches, designed the new facility, and worship continues there today.

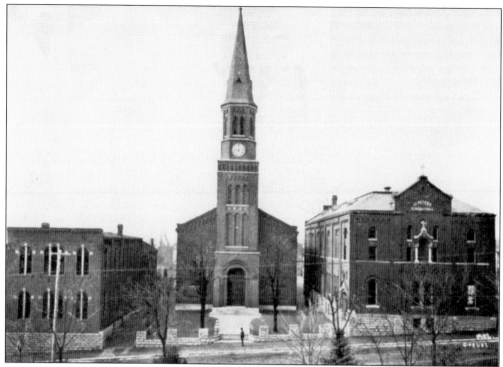

The spire on the new St. Peter German Catholic Church rose high above the surrounding residential and commercial rooftops. The church opened a parish school, which continues today. The church's name today is St. Peter Catholic Church.

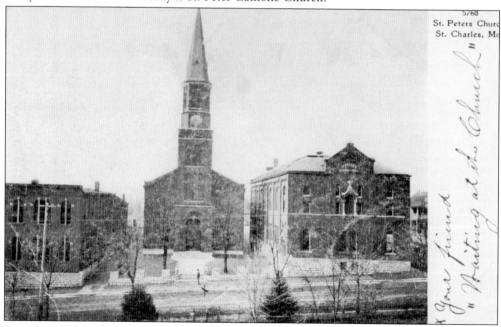

Few changes have been made to the exterior of St. Peter Catholic Church. In the summer of 1910, the steeple roof was renovated and a cross was installed. The top of the steeple is 186 feet from the ground. The site of St. Joseph Hospital was chosen for its proximity to the church.

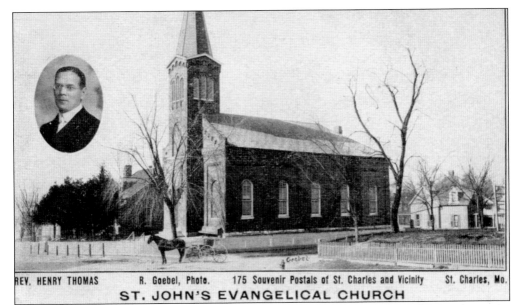

ST. JOHN'S EVANGELICAL CHURCH

St. John's German Evangelical Church began in 1868 when city-dwelling members of a German Evangelical church located outside town decided to form a separate church closer to their homes in St. Charles. Located at Fifth and Jackson Streets, the building was designed by architect Johann Heinrich Stumberg, who also designed St. Charles's Immanuel Lutheran and St. Peter Catholic Churches.

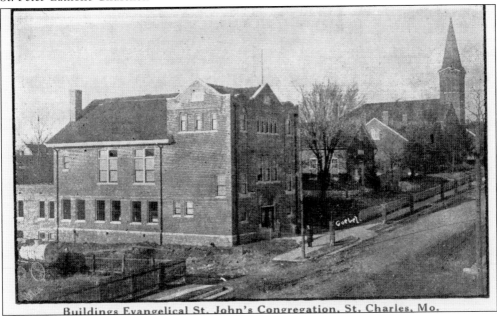

Buildings Evangelical St. John's Congregation. St. Charles, Mo.

St. John's German Evangelical Church building was dedicated in 1869. A bell was placed in the tower in 1872. Other improvements and additions have been made over the years. In 1868, the church opened a German-English parochial school. A 1891 city directory advertisement reads, "Instruction given in the following branches: Religion, Arithmetic, Reading, Writing, Grammar, Geography, History, Drawing." At that time, the school had two teachers and 106 students. The school closed in 1930.

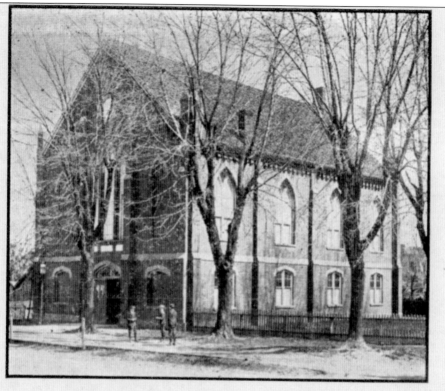

First Presbyterian Church, St. Charles, Mo.

The First Presbyterian Church of St. Charles organized in 1818, and it was the first Protestant church in St. Charles. The stately building pictured here was located at the corner of Fifth and Madison Streets until it was razed in the 1960s to make way for St. Charles's new post office.

First Presbyterian Church St. Charles, M

Organized August 29th, 1818

CELEBRATION SEPT. 15th, 1918.

In 1873, there were 10 churches in St. Charles, a town of about 9,000. Catholics, Methodists, Lutherans, and Presbyterians formed the largest congregations as of 1885. The 1908 city directory reported that St. Charles was home to 13 large, prosperous churches. In addition to worship services, churches offered social gatherings, dinners, and festivals. Church-based benevolent aid societies helped the poor in the days before welfare assistance existed.

JEFFERSON STREET
PRESBYTERIAN CHURCH

No. 21

FIFTH STREET
METHODIST CHURCH

No. 17

MADISON STREET
PRESBYTERIAN CHURCH

No. 21

St. Charles residents held strong opinions about the Civil War and slavery. Jefferson Street Presbyterian Church (left) was formed in 1867 as a result of a division in the congregation. A 1911 storm damaged the roof and destroyed the building's original steeple. The steeple was not restored to its original height. The Fifth Street Methodist Church on Main Street was established in the early 1800s.

BAPTIST CHURCH

No. 21

GERMAN METHODIST CHURCH

No. 20

GERMAN EVANGELICAL CHURCH

No. 21

The German Methodist Church was organized in 1847 and moved into a small building in 1849. It grew, and a larger church was built at Second and Madison Streets in 1868. In February 1876, a tornado hit the spire, twisted it, and sent it spinning up and then back down point first. The church lost members in the 1870s, and the congregation decided to return to its original building at Fourth and Jackson Streets (center). The Baptist Church was established in 1888, and it purchased the building vacated by the German Methodist Church on Second Street (left).

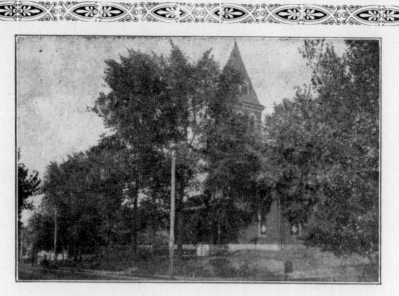

Fifth Street Methodist Church, St. Charles, Mo.

Catherine Collier, widow and devout Methodist, moved to Main Street with her young sons and started the Methodist Society. She donated land on Main Street for a church, and worship was held there until 1852. The congregation grew, so a new structure was built, and worship took place there until 1896. That year, the congregation moved to an existing church facility at Washington and Fifth Streets, and the name changed to Fifth Street Methodist Church. In 1953, a fire destroyed the beautiful building, and in short order, a new brick structure on Clay Street (now First Capitol Drive) was built. St. John's Evangelical Church, located just down the street, offered the Fifth Street congregation use of its facilities while their new structure was under construction. The congregation moved into its new structure and continues today as First United Methodist Church.

Nine

WEATHER
COMPLICATIONS

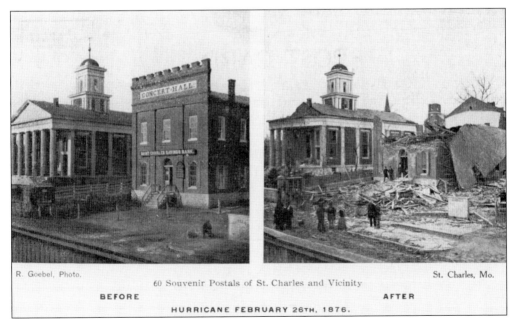

R. Goebel, Photo. St. Charles, Mo.

60 Souvenir Postals of St. Charles and Vicinity

BEFORE AFTER

HURRICANE FEBRUARY 26TH, 1876.

St. Charles's original courthouse was built on South Main Street in 1849. Beside it sat the concert hall. On Sunday, February 26, 1876, at midday, a tornado hit St. Charles. The twister destroyed the concert hall and damaged the courthouse and other buildings. For decades, local newspapers marked the anniversary of the storm.

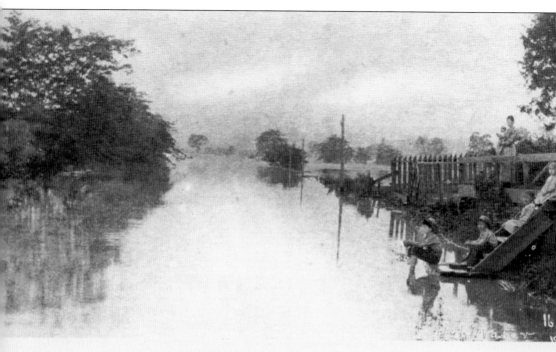

60 Souvenir Postal Cards of St. Charles and Vicinity St. Charles

THE ROAD FROM BOCHERTTOWN TO ST. CHARLES, MO.—High Water June 7, 8, 9, 1903

Floods from the Missouri River have occurred in 1877, 1881, 1903, 1922, 1927, 1943, 1944, and 1993. Those who lived and farmed on land near the river expected flooding and learned to live with it. The road leading north from St. Charles to the Boschertown area was completely flooded in June 1903, with water reaching the top of fence posts in some areas. Although levees have been built and water management practices are implemented, some low-lying areas continue to flood with the spring rains.

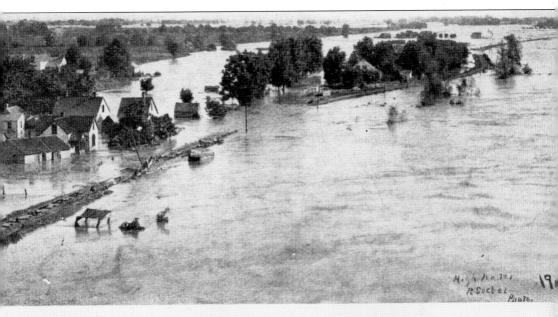

60 Souvenir Postal Cards of St. Charles and Vicinity

GLIMPSE FROM WABASH R. R. BRIDGE. LOOKING NORTH.—High Water June 7, 8, 9, 1903

St. Charles, Mo.,

In this 1903 image captured by Rudolph Goebel from the Wabash Railroad Bridge, floodwater has inundated farmland and crops near St. Charles. Many farmers moved their livestock to higher ground.

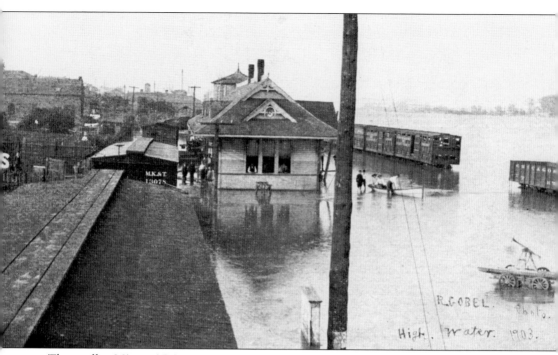

The swollen Missouri River covers St. Charles's railroad tracks and the lower levels of the MKT railroad station in 1903. Train engineers were forced to abandon freight cars. At that time, the railroad station was located farther from the river. In the late 1970s, the structure was moved closer to the river and rotated 180 degrees to make way for a road. The building was also restored to its original state and today looks much as it did 100 years ago.

Big Trees Blown Down and Destroyed in St. Charles' Great Storm of July 7, 1915

Located near Tornado Alley, St. Charles had been the scene of several damaging tornadoes over the years. The tornado that hit July 7, 1915, destroyed or damaged many houses, buildings, properties, and beautiful trees. This scene from a St. Charles neighborhood shows the destruction resulting from the storm's high winds.

The tornado that hit St. Charles on July 7, 1915, destroyed the ornate sanctuary of St. Charles Borromeo Catholic Church. The storm reduced the sturdy stone structure and its stately spire to rubble in a matter of minutes. It took the congregation and workers just nine months to clear the damage and rebuild a larger stone structure with elaborate interior details.

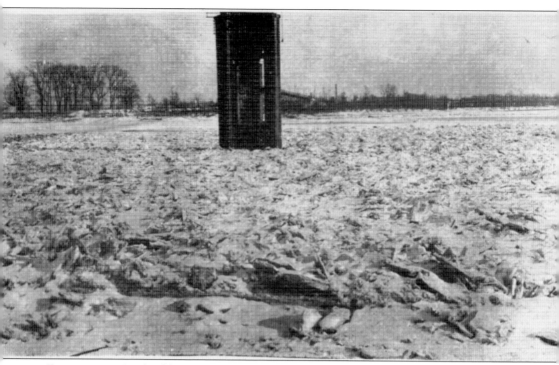

Extreme, sustained cold temperatures are needed to freeze the Missouri River solid. While it is a rare occurrence, the power of the river seems diminished. Ice can be up to 18 inches thick, and on occasion, it creaks and groans. In the days before refrigeration, large groups of men harvested ice to store for use in the summer. It was an arduous and time-consuming task. First, the snow was removed. Square grids were measured and grooves cut into the ice by horses pulling sharp styli across the surface. Ice saws, picks, and tongs were then used to cut and free the blocks. The blocks were transported by wagon to an icehouse and stored between thick layers of sawdust.

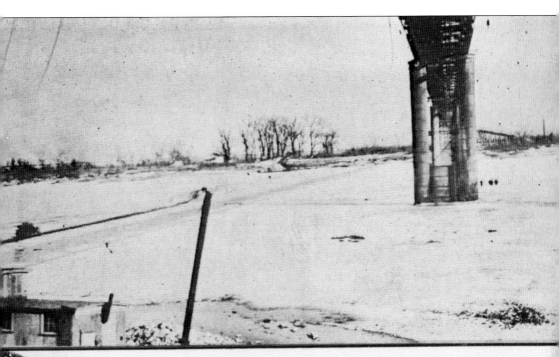

n the River, St. Charles, Mo., Automobiles and People crossed the ice on a road all Winter

The surface of the Missouri River is frozen solid in this early-20th-century image taken from under the Highway Bridge. Over the years, residents crossed the river by foot and even automobile to reach St. Louis County.

BIBLIOGRAPHY

Breslow, Lori. *Small Town*. St. Charles, MO: John J. Buse Historical Museum, 1977.

Brown, Daniel T. *Small Glories: A Memoir of Southern St. Charles County and the Formation of the Francis Howell School District*. St. Charles, MO: Howell Foundation, 2003.

Brown, Jo Ann. *St. Charles Borromeo, 200 Years of Faith*. St. Louis, MO: Patrice Press, 1991.

Buse, John J. *In His Own Hand, A Historical Scrapbook of St. Charles County, Missouri*. St. Charles, MO: Scholin Brothers, 1998.

Drummond, Malcolm C. *Historic Sites in St. Charles County, Missouri*. St. Charles, MO: Harland Bartholomew, 1976.

Ehlmann, Steve. *Crossroads: A History of St. Charles County, Missouri*. Marceline, MO: Walsworth, 2005.

Foley, William E. *A History of Missouri 1673–1820, Vol. 1*. Columbia, MO: University of Missouri, 1971.

Livingston, Stephen D. *Agricultural History of St. Charles County, Missouri*. St. Charles, MO: American Revolution Bicentennial Committee of St. Charles County, 1976.

Popp, William. *The Life and Work of Rudolph Goebel*. St. Charles, MO: St. Charles County Historical Society, 2010.

Rothwell, Dan A. *Along the Boone's Lick Road, Missouri's Contribution to Our First Transcontinental Route, U.S. Highway 40*. Chesterfield, MO: Young at Heart Publishing, 1999.

St. Charles County Historical Society. *Heritage Treasures*. St. Charles, MO: St. Charles County Historical Society, 2006.

———. *Missouri State Gazetteer and Business Directory*, 1876–1879, 1891–1892.

———. *Polk's St. Charles City Directory*. Peoria, IL: Leshnick Directory Co., 1892, 1903-1904, 1906, 1908-1909, 1916, 1918, 1921–1922, 1932, 1939.

———. *To Manufacturing and Mercantile Interests and Real Estate Investors*. St. Charles, MO: City of St. Charles, 1908.

———. *US Department of the Interior, National Park Service, National Register of Historic Places Registration Form – St. Charles Historic District (Boundary Increase III)*. June 7, 1996.

About the
Organization

The St. Charles County Historical Society is a nonprofit 501(c)(3) corporation founded in 1956. It is dedicated to the preservation of information, landmarks, and artifacts related to county history. It encourages interest in the rich history and culture of the county. The society and its archives occupy the Old Market House, 101 South Main Street. Parts of the building date to 1832. The building began as a public market house and later served as city hall and a police station.

DISCOVER THOUSANDS OF LOCAL HISTORY BOOKS FEATURING MILLIONS OF VINTAGE IMAGES

Arcadia Publishing, the leading local history publisher in the United States, is committed to making history accessible and meaningful through publishing books that celebrate and preserve the heritage of America's people and places.

Find more books like this at
www.arcadiapublishing.com

Search for your hometown history, your old stomping grounds, and even your favorite sports team.